It's essentially an idea that you can't teach art, but if you're around artists you might pick up something. John Baldessari

HARDCOVER brings together the work of 20 contemporary artists who work with photography and the moving image. What connects the contributors is that they all studied at the Photography Department of the Royal College of Art and graduated in 2011.

We wanted to make a publication that moves beyond the conventions established by the practice of each of the artists, and asked for works conceived explicitly for the printed page. Hence, when creating a specific new work for HARDCOVER, the artist had to reconsider his or her own practice in view of the book to be produced.

Douglas Park describes HARDCOVER as follows: "Contended with throughout every stage and aspect is the tradition of collective, invited and submitting contributor's use of pages and publication as laboratory, atelier, playground and venue, not simply promotional brochure and portable showroom display."

HARDCOVER, alongside visual and text-based conversations between artists and writers, includes new writing by Simon Baker, Olivier Richon, Vanessa Boni, Mike Sperlinger and Leslie Dick.

For this publication we collaborated with the Communications Department at the RCA and would like to thank Matthew Stuart, Pedro Pina and David Gibson for their creative input into the book. Special thanks to Vanessa Boni, Curating Department, who generously devoted her inventive energy to the project and to Tom Pope and Andrew Lacon, who lent their time and expert advice, from the initial stages of the book, right through to its completion.

Also we would like to thank Duncan McCorquodale at Black Dog Publishing for his commitment to the project. With HARDCOVER we aim to set the production of future annual publications in collaboration with Black Dog Publishing into motion.

We hope that HARDCOVER can become a tool to generate diverse types of conceptual exchanges and aesthetic pleasures.

Rut Blees Luxemburg, Editor

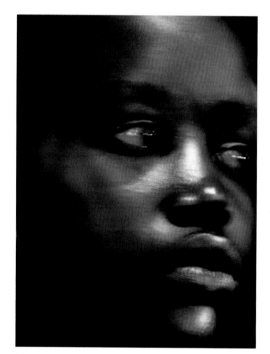

Fig.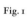

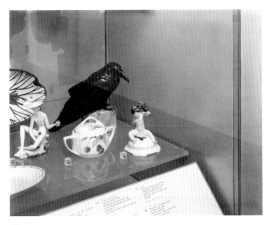

Fig. 2

Fig. 3

Fig. 4

Fig. 5

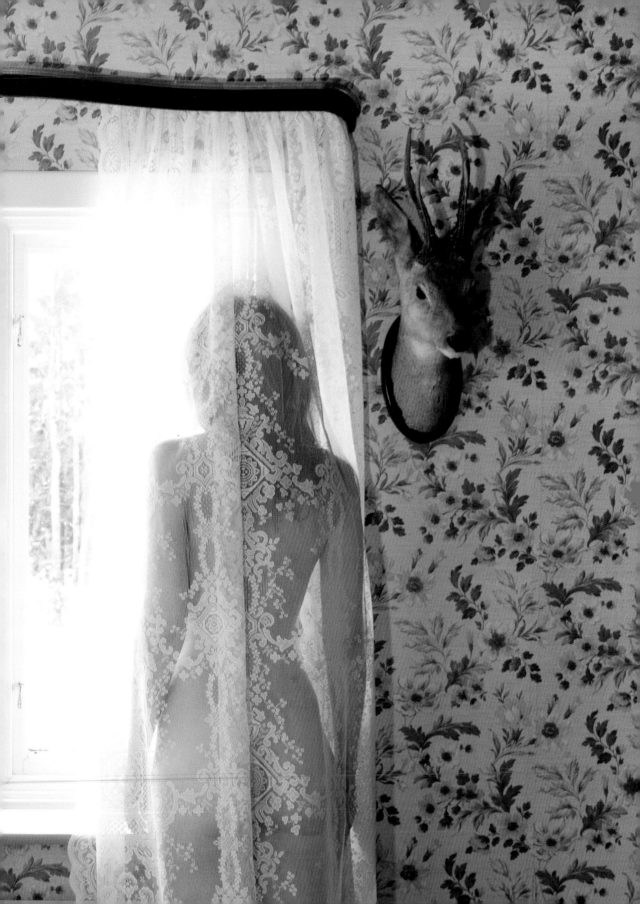

DETERMINANTS OF DISPLAY NOTES [PARTS I–IV]

Vanessa Boni

I

"NOTHING WILL HAVE TAKEN PLACE BUT PLACE" spills from one side of the spine to the other in a constellation of intersecting sentences. The form of these words is as evocative as their meaning. Stéphane Mallarmé is often referred to as the first writer who experimented with the visual form of poetry. *Un coup de dés jamais n'abolira le hasard/Dice Thrown Will Never Annul Chance*, 1895, was the first. For Mallarmé, the visual layout of the text and the placement, size and typography of the words, were all determinants of the visual and spatial possibilities of literature in its printed form, through which he looked to challenge standard linguistic arrangements. Visual poetry emerged exactly when the structure of the text incorporated the potential of its own visual appearance. In *Un coup de dés jamais* the blank spaces of the page intervene with the text at every turn, breaking its sentences and splitting its syntax. When Mallarmé writes "nothing will have taken place but place", it seems to suggest that the pages' blank spaces do not in fact elicit a place of nothingness, but rather it is in this nothingness that the presence of a place becomes visible. It is in this way that the poem communicates, demonstrates and reveals the form and condition of its medium of communication.

VANESSA BONI

II

So you should simply make the instant
Stand out, without in the process hiding
What you are making it stand out from.
 Give your acting
That progression of one-thing-after-another,
 that attitude of
Working up what you have taken on. In
 this way
You will show the flow of events and also
 the course
Of your work, permitting the spectator
To experience the Now on many levels,
 coming from previously and
Merging into Afterwards, also having
 much else Now
Alongside it.*

Theatre Poem, c. 1938 by Bertold Brecht

*

This citation is from the essay "Ways of
Remembering" by John Berger published in
Camerawork, no. 10, July 1978.

III

A camera ascends in the corner of an empty gallery space from floor to ceiling, and then tracks across the upper edge of the room until it reaches an air ventilation grid. This is one of the first shots in *A Study of Relationships between Inner and Outer Space*, 1969, by David Lamelas. The film is an analysis of the practical, organisational and social conditions that make up the environment of the gallery, both within the walls of the institution and the city of London, in which it is located. The film begins with examining the architectural space of the gallery drawing attention to its functional elements through an explanation of its dimensions, lighting system and acoustics— exposing the raw conditions of the gallery's structure. The film extends its focus to the environment of the surrounding streets, where people are interviewed in anticipation of the first man landing on the moon. *A Study of Relationships* is an investigation into the constant negotiation between interior and exterior space, a duality which operates on both sides of the separation. As, when exhibiting artworks in a gallery there are certain determinants for display; there are determinants for display within the space of a book. The edges of a book both describe its interior areas and delineate it from the space beyond its frame. Rather than an end, such conditions for presenting works as these can become a gesture or a means, which form part of the communicative properties of the work itself.

VANESSA BONI

IV

Books have a long history in distributing photographic images, but there has been little published discussion on this subject. *Camerawork*, established in London in the mid-70s was one of the few photographic journals to date whose approach was dedicated to a critical and contextual analysis of photography and the relations between producers, forms of distribution and the viewer. John A Walker's essay "Context as a Determinant of Photographic Meaning" was first published in *Camerawork* in 1980. Walker mainly focuses his discussion on the display and media in which photographs appear; the ways in which images circulate through social and institutional networks; and how these different contexts have an effect on the meaning and function of the image. Walker explains; "By 'circulation' is meant the distribution/transmission of an image through the communication networks of the world and its movement through various social strata and institutions." It is often the case that the division between the image's production and circulation remains, even in the making of exhibitions. It is this distance between what is made and how it is documented and distributed that deserves critical consideration. By producing work specifically for a publication where the form of the book is itself taken into consideration, one could say that the production of work and its dissemination draw closer, making visible a continuity between its process and context. This results in shift from a documentary method of recording and representation, to one that establishes the book as an active part in the process of making work.

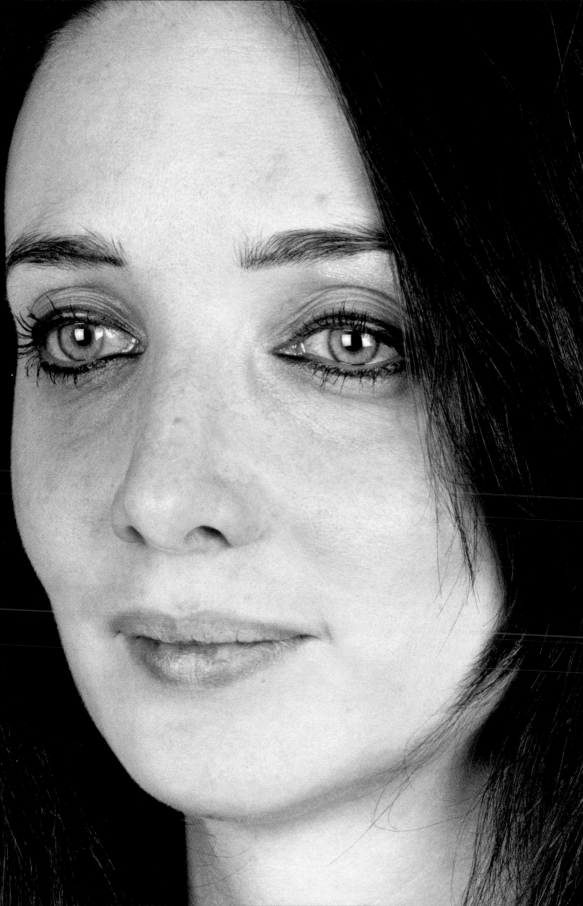

The Tender Interval, 2010

16mm film with optical sound

00:15

00:00

Close up.

A domestic window shot from
outside, almost filling the film
frame. There is ivy surrounding
it, creeping over the wooden
surround and gently brushing
against the edge of the glass as
the wind slowly ripples through it.

Though the window frame is in
sharp focus, the interior of the
room is softer and much more
difficult to read through the
reflection of the dusty glass
pane. We can barely distinguish
the shape of the furniture,
nor do we know exactly what we
are supposed to be looking at.

The room suddenly comes
into focus.

It is empty.

Cut back to the window, seen
from outside as before. This
time, through it, we can see the
girl facing away from the camera,
sitting at a rough work table.

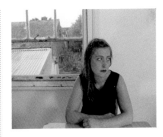

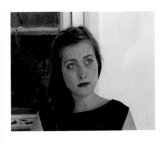

01:48

01:02

Cut to a misty shot of a barren
shingle beach.

Where is this? Is this a real
location or is it a fiction
put in place by the artist?
Cut. We are now closer. Cut.
And, again, closer. Cut.

The camera pans deliberately
across the landscape. As we
think about the possibilities
of imagined space, we become
increasingly aware of the film's
soundtrack moving in and out
of our consciousness like
a long distant memory…

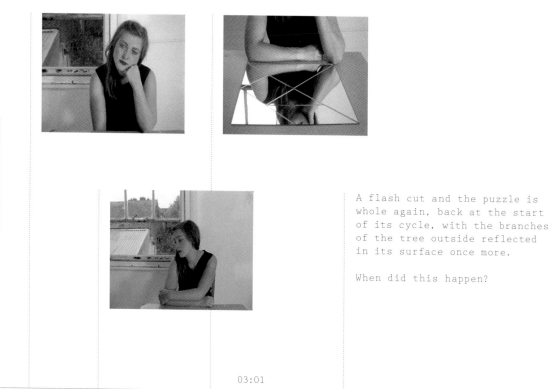

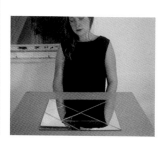

A flash cut and the puzzle is
whole again, back at the start
of its cycle, with the branches
of the tree outside reflected
in its surface once more.

When did this happen?

03:01

03:30

Again, the sound that is weaving
itself throughout the film begins
to awaken thoughts and ideas
inside us.

We move closer to the puzzle
until it fills the film frame.
It is now reflecting fragments
of the tree outside.

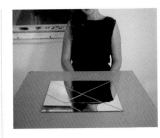

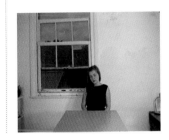

Now a solitary white butterfly
is faintly reflected in the
puzzle's surface.

A flash frame and we see it
in reverse, fluttering past
the window, through the sky
and out of the film frame.

04:00

05:00

04:27

Back to the puzzle. It is again
complete, back in its original
square formation, yet it now
reflects the sky.

We notice that the sounds we
hear no longer correlate with
the actions that we see on screen.
We hear the dull scraping of the
mirrored pieces moving against the
table top but the puzzle itself
remains static.

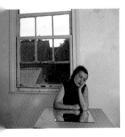

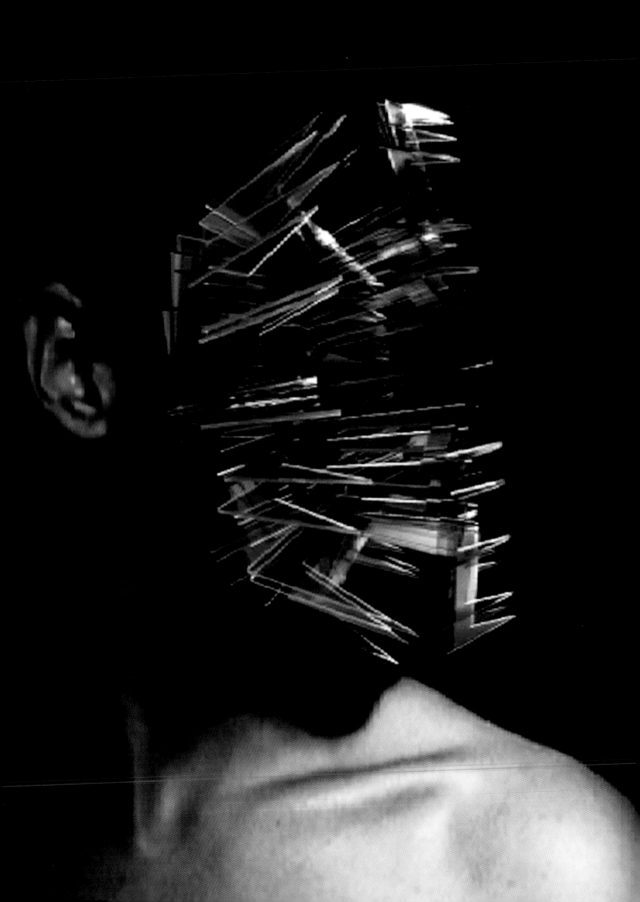

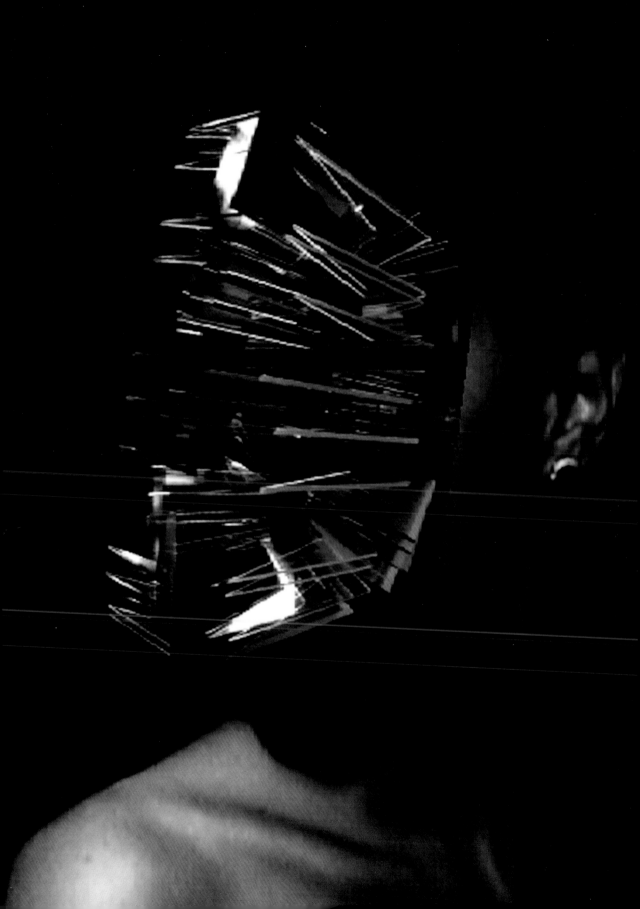

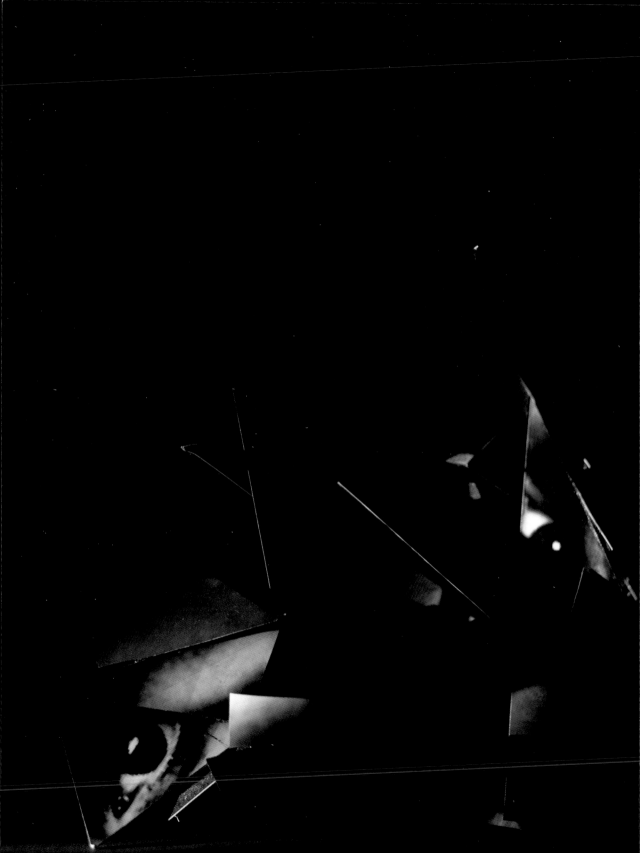

What if I wanted to turn
into your prosthesis?
As a prosthesis, I would be
so much a part of you that you
could not function without me.
But I would also keep my
separateness. I see a male
and a female figure who seem
to look at each other. Rather
than wearing masks, it is
as if two gyrating sculptures
had been superimposed upon
their faces. Spiky machine
heads with varying rotational
speeds replace the eyes,
the noses, the mouths.
My monstrous moving earring
made of sharp bits of ice,
cutting splinters of glass
or jagged slices of diamond,
allows me to penetrate you,
to perforate the surface
of your skin and dig deep
into your body. I circulate
inside you as I make my
way across your entrails.
I am your tube. Yet at the
same time my ring forever
maintains me at a distance,
even before you cover your
face with your own jewellery
and the mating season begins.
Now our floating bodies
dance and our artificial faces
spin. We perform a courtship
infinitely tender and violent.
Our shoulders touch but it
remains a top-heavy affair.
We are slashers who respect
each other as artists.

Alexander García Düttmann

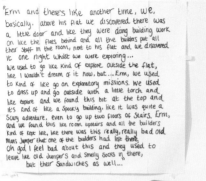

"Erm and there's like another time, we, basically, above his flat we discovered there was a little door and like they were doing building work on like the flats behind and all the builders put all their stuff in the room, next to his flat and we discovered it one night whilst we were exploring...
We used to go like kind of explore outside the flat, like I wouldn't dream of it now, but...Erm, we used to kind of like go on exploratory missions. We used to dress up and go outside with a little torch and like explore and we found this bit at the top and it's kind of like a spooky building, like it was quite a scary adventure, even to go up two floors of stairs. Erm, and we found this like room upstairs and all the builders kind of kept like, like there was this really, really bad old Muns jumper that one of the builders had left there.
Oh god I feel bad about this and they used to leave like old jumpers and smelly socks in there,
but their sandwiches as well..."

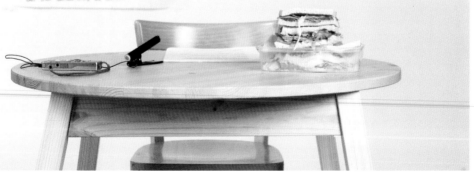

"Erm and there's like another time, basically above his flat we discovered there was a little door and like they were doing building work on the, like, the student flats behind and all the builders put all their stuff in the room, next to his flat and we discovered it one night whilst we were exploring. We used to go like, kind of, explore outside the flat, like I wouldn't dream of it now but, erm we used to kind of like go on exploratory missions. We used to dress up and go outside with a little torch and like explore and we found this bit at the top and it's kind of a spooky building, like it was quite a scary adventure, even to go up two floors of stairs. Erm and we found this bad old mans jumper that one of the builders had left their. Oh god I feel really bad about this and they used to leave like old jumpers and like smelly socks in there,

but their sandwiches as well..."

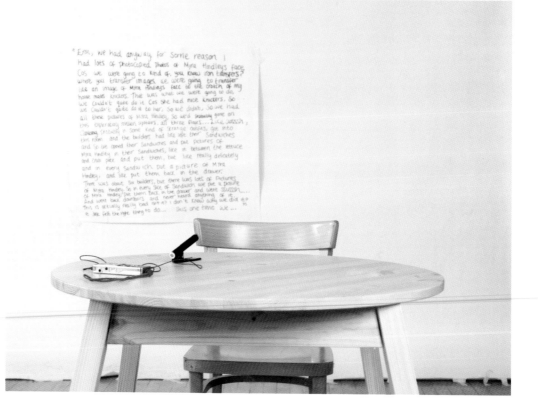

"Erm and there's like another time, we, basically. above his flat we discovered there was a little door and like they were doing building work on like the flats behind and all the builders put all their stuff in the room, next to his flat and we discovered it one night whilst we were exploring...
We used to go like kind of explore outside the flat, like I wouldn't dream of it now, but...Erm, we used to kind of like go on exploratory missions. We used to dress up and go outside with a little torch and like explore and we found this bit at the top and it's kind of like a spooky building, like it was quite a scary adventure, even to go up two floors of stairs. Erm, and we found this like room upstairs and all the builders kind of kept like, like there was this really, really bad old Mars Jumper that one of the builders had left there
Oh god I feel bad about this and they used to leave like old jumpers and smelly socks in there, but their sandwiches as well..."

" Erm, we had anyway for some reason I had lots of photocopied photos of Myra Hindley's face. Cos we were going to kind of, you know iron transfers? where you transfer images, we were going to transfer like an image of Myra Hindley's face to the crotch of my house maids knickers. That was what we were going to do, we couldn't quite do it Cos she had nice knickers. So we couldn't quite do it to her, So we didn't, so we had all these pictures of Myra Hindley, so we'd probably gone on this exploratory mission upstairs, all three floors... Like suussh, claxing, probably in some kind of strange outfits, got into this room and the builders had like left their sandwiches and so we opened their sandwiches and put pictures of Myra Hindley in their sandwiches, like in between the lettuce and crab pate and put them, but like really delicately and in every sandwich put a picture of Myra Hindley, and like put them back in the drawer.
There was about six builders, but there was lots of Pictures of Myra Hindley. So in every slice of sandwich we put a picture of Myra Hindley, put them back in the drawer and went ssusssh... And went back downstairs and never heard anything of it. this is actually really bad isn't it? I don't know why we did it? it just felt the right thing to do... this one time we..."

"Erm and there's like another time, we, basically, above his flat we discovered there was a little door and like they were doing building on like the flats behind and all the builders put all their stuff in the room, next to his flat and we disco it one night whilst we were exploring... we used to go like kind of explore outside the fl like I wouldn't dream of it now, but...Erm, we u to kind of like go on exploratory missions. We t to dress up and go outside with a little torch a like explore and we found this bit at the top it's kind of like a spooky building, like it was gu scary adventure, even to go up two floors of stairs, and we found this bit room upstairs and all the bui

"Erm, we had anyway for some reason I lots of photocopied photos of Myra Hindley's face, were going to kind of, you know, iron transfers? transfer images, we were going to transfer like a Myra Hindley's face to the crotch of my was. That was what we were going to do, so have do it cos she had nice knickers. So she didn't, so we had lots of Myra Hindley, so we'd probably gone on mission upstairs, all three floors... like sussh in some kind of strange outfits, got into the builders had like left their sandwiches of their sandwiches and put pictures of their sandwiches, like in between the lettuce and put them, but like really delicately sandwich put a picture of Myra

" Erm we had, anyway, for some reason,
I had lots of photocopied photos of
Myra Hindley's face, cos we were
going to kind of, you know, iron transfers,
where you transfer images, we were
going to transfer like an image of Myra.
Hindley's face to the crotch of my house
mates knickers. That was what we were
going to do, but we couldn't quite do it,
we couldn't quite do it cos she had nice
knickers. So we couldn't quite do it to
her, so we didn't.
So we had all these pictures of Myra
Hindley, so we'd gone on this exploratory
mission upstairs, all three floors...
Like susssh, climbing. Probably in some
kind of strange outfits, got into this
room and the builders had left like their
sandwiches and so we opened their
sandwiches and put pictures of
Myra Hindley in their sandwiches, like
in between the lettuce and the crab pate
and put them, but like really delicately in
every sandwich put a picture of Myra
Hindley, and like put them back in
the drawer, there was about six builders,
but there was lots of pictures of Myra
Hindley, so in every slice of sandwich
we put a picture of Myra Hindley,
put them back in the drawers and
went ssussh. And went back downstairs
and never heard anything of it.

This is actually really bad isn't it?
I don't know why we did it?

It just felt like the right thing to
do... One time we..."

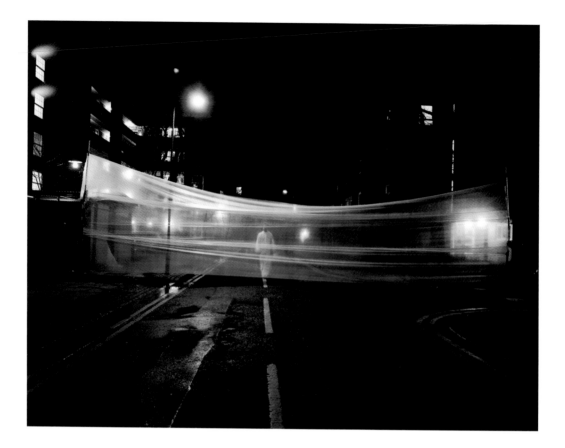

The Good Choice

Kai: I feel that I never know what I really want when I am making my work. The only thing I know is that I want to make something that I want to see myself.

Hiroshi: Sometimes I definitely know what I want. For example, when shooting a still life I have a special feeling for, I just go for it. Without having to worry about its feelings. I just go ahead. I already have one aspect that I want to show. I already have an idea in my head, what I want from what I'm seeing in front of me. But as I arrange the objects there is an interaction, then the idea develops, it keeps changing. They do not really talk to me,

although there might be a silent suggestion.

K: So you do not enjoy that embarrassment? Because I think I really do, although it is very highly stressful.

H: I don't know, I get quite exhausted when taking pictures of people. I just keep hoping that something will happen. It might take eight hours, I'm quietly trying to get something out of the person I'm photographing, without really telling them what to do. It is the thrill of expecting something to happen.

K: Doesn't taking photographs isolate you from that situation even more?

H: I didn't think about that, because I wanted to take a part of London for myself. To capture a particular scene and keep it in front of me, I felt part of it. After doing that for some time, I thought I would like to take pictures of people. At that time, I was not sure if I would like it or not. Looking at fashion magazines, I thought I wanted to take fashion pictures.

K: What did you think about conceptual art in the 60s? People like the Bechers doing typology, and artists like Douglas Huebler using photography as part of their art work.

H: As long as the images are interesting to me, I will look at them. Interesting concepts alone do not make me look at photographs. In the 60s, I didn't know about the photographers you mentioned. At that time in 1966 I was interested in Contemporary Photography in New York. Photographers such as Lee Friedlander, Bruce Davidson, Duane Michals and Diane Arbus photographed the most banal situations in ways that made you want to look at them. I also found Les Krims photographs of arranged situations quite intriguing and very different from the great

French photographer Jacques-Henri Lartigue who already was photographing staged moments.

K: 90 per cent of the people in Tokyo said they think my work is too direct, that they prefer work that is more ambiguous, simple and abstract. I didn't have such reactions in London. On the contrary, I have been told that I must be more direct with my work and stop being metaphorical and abstract. Do you get very different reactions when you show in different countries?

H: Always the same. "Too commercial."

K: Now you are being cynical. What do you think in general?

H: Well, people in London used to say my photographs were very oriental. In Tokyo, people used to say my pictures were very European, about the same pictures.

K: I had a European curator saying my work looks like Daido and Araki, and my tutor says my work is neo-Zen....

H: I've started to think that what I'm doing every day is really a kind of installation. I am photographing it now. I might actually show my

installations in the future. I was inspired when I saw your exhibition in Liverpool, where I liked your installation with the mirror and the tape-recorder.... I think if you just keep looking at the pictures, it becomes very quiet. To break that, it is good to add something three-dimensional.

K: Let's go back to what is important for us in our work, and also to what is the theme that ties together the different projects that one produces, if there is one. I was drawn to the gap between how I see myself, with how other people see me. I do not want to be put into a category by someone or some system. At the same time I want to belong somewhere, only to find out finally that I cannot belong anywhere. This is the sort of dilemma I keep going around and around all the time. I create it myself, while other systems and people create it for me. The performative side of my work perhaps stems from this, trying to push the boundaries, playing with what I can be, to manipulate or to be controlled by the other. This seems somehow to have become the whole purpose of making my work.

H: For me, as I have mentioned before, the feeling of not belonging when I arrived in London at the age of 18 was what made me start taking pictures. I used the act of taking photographs as a means of getting the satisfaction of belonging to the world around me. The funny thing was that even when I later returned to Japan, I had the same feeling of not belonging there either. I was very conscious about that point. In my work, I try to fix an image, which is behind the mist in my mind. When finally I see something that I like myself, I show it to other people.

K: Where does the colour come from? Your work is really colourful. I think European artists are very scared of using strong colours, except artists like Pipilotti Rist who uses really vivid colours.

H: It is something totally natural to me. Also, strong colours have an impact on people. I like it a lot. Just as opera uses colour to excite the audience. Lots of people say that my work looks commercial, because of the beautiful colours and the rather large empty space around the image. I do not agree with that at all. Of course, I take pictures using monochrome colours too. It really depends on the subject matter. The important thing when making an image is to realise if you want to communicate what is actually there, then that will come across to the viewer.

K: I do not feel that images or photographs communicate enough in the way that I want, nor that it gives an experience to the audience in the way you are interested in. I am really bored if I go

to a gallery, then just see images after images on the wall. But this does not mean that I want to read long texts all the time. Recently, I went to see Modern British Sculpture, where my favourites were the moai and sphinx statues. I only know what it is made of and when and where it was made. And that was enough, I just felt like I was talking to the universe, and I was on a spacecraft that takes me out of this planet. There was not anything unnecessary, and I felt those two statues defined the whole space. I could not care less about all of the other work, I just walked past, although now that I think about it, there were some other interesting things. Are words important to you? Do you express your work just with titles and images?

H: Even an installation by me would not involve many words. It would be simply image related. It is about how I would make a connection between one piece and another, and how I would combine the objects. There would be titles.

K: Then, maybe this conversation is not so important to you either, would you rather just use some images, to make an installation on the pages to communicate with the reader?

H: I think I cannot communicate with other people much, so probably the reader does not really get what I am going on about. Don't you think so?

K: Did you want me to become a photographer?

H: Yes, once you started showing an interest in photography. I was really delighted to be able to share my experience and knowledge by exposing you to various situations.

TRANSLATOR'S INTRODUCTION: ON MARIANNE WEX

Mike Sperlinger

My copy of Marianne Wex's 1979 book is a translation. The English title is: *Let's Take Back Our Space: 'Female' and 'Male' Body Language as a Result of Patriarchal Structures.* The original German title is not given anywhere in the book, but I recently discovered it: *'Weibliche' und 'männliche' Körpersprache als Folge patriarchalischer Machtverhältnisse.* That opening, scare-quoted exhortation seems to have been peculiar to the Anglophone edition.

 Let's Take Back Our Space, an elegant landscape-format book of black and white images, might be classified, non-exhaustively, as a photographic typology fashioned into a feminist broadside; an encyclopedia of gesture; an anthropological portrait of Hamburg in the 1970s; a monomaniacal tract on art history; a neglected classic of appropriation aesthetics; an autobiography; an exorcism. Wex had originally started out as a painter, but an interest in body language led her to take 1,000s of street photographs over several years; gradually, she began to categorise the images according to their body language and to draw conclusions about the gender roles they reflected. She also drew on a variety of found imagery including photojournalism, advertisements, art historical reproductions, family album snapshots, pornography, mail order catalogue clippings, publicity shots, television and film stills, etc.. Wex rephotographed all these other sources and combined them with her own images into large collaged panels for exhibition; these collages formed the source material for the book.

 The book is organised thematically: the first half focuses on contemporary images and groups them by posture

MIKE SPERLINGER

"Seated persons, leg and feet positions", "Standing persons, arm and hand positions", etc.. On the left hand of each spread, images of men in a given posture run along the top and of women along the bottom; the right hand spread tends to be sparer, often reserved for one or two 'exceptions' to the stereotypically gendered gestures. The second half focuses on statuary, from ancient Egypt to the nineteenth century, and includes a number of short texts on art history, gender and socialisation, and accounts of Wex's own experiences.

The overall effect is vertiginous. The sheer weight of images is convincing, while also, in its obsessiveness, slightly comic. Cumulatively, the sheer ruthlessness of Wex's cropping—both in terms of the framing of the images and the bracketing of any context other than the gestural—amplifies the book's polemic to the point of discomfort. On page 102, for example, we find a man standing on a field of bodies, Jewish victims of Nazi genocide, juxtaposed with, amongst others, a muscleman from a home exercise ad and a tourist on a Bangkok beach. In the service of shattering stereotypes, individuals are assembled to illustrate them. Similarly, the force of repetition renders images ambiguous: the same images recur to illustrate different stereotypes (once for "arm and hand position", then again for "leg and feet"), while the resemblance of the individuals in each pose to one another, the sheer rigidity of the stereotypes, becomes ridiculous, especially when a series of shots of unselfconscious Hamburg pedestrians is bookended by Marilyn or another media 'ideal'. In these moments the polemic seems almost to burst its banks and become something more metaphysical, Dionysian, anarchic—like Bataille's famous assertion that, "the world is purely parodic, in other words, that each thing seen is the parody of another, or is the same thing in a deceptive form". Each man or woman in the line-up seems like a travesty of the next, simply another translation with no original.

Wex's project, in fact, as outlined in the book, is like a cascading series of transitions and translations, a concatenation of transformations: from painting to photography; from body to image; from heterosexuality to lesbianism; from aesthetics to politics; from reconciliation to retaking space; and, not incidentally, from artwork to printed page. When I first saw the original collaged panels, which

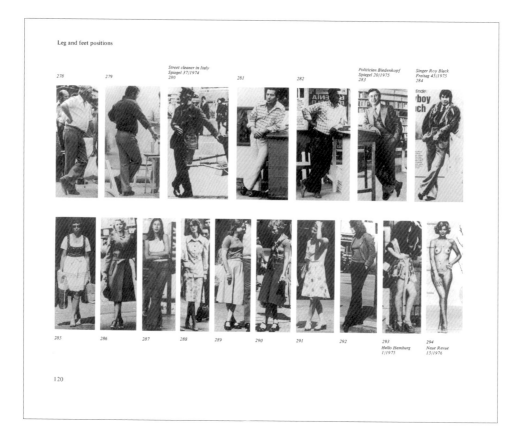

Leg and feet positions

Street cleaner in Italy
Spiegel 37/1974

Politician Biedenkopf
Spiegel 20/1975

Singer Roy Black
Freitag 45/1975

278 · 279 · 280 · 281 · 282 · 283 · 284

285 · 286 · 287 · 288 · 289 · 290 · 291 · 292 · 293 *Hello Hamburg 1/1975* · 294 *Neue Revue 15/1976*

120

MIKE SPERLINGER

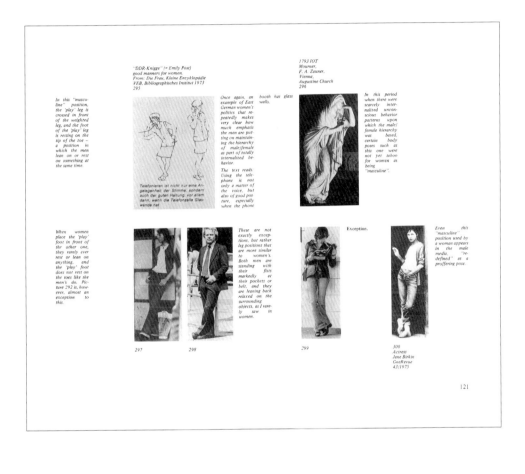

"DDR-Knigge" (= Emily Post)
good manners for women.
From: Die Frau, Kleine Enzyklopädie
VEB, Bibliographisches Institut 1973
295

1793 IOT
Mourner,
F. A. Zauner,
Vienna,
Augustine Church
296

In this "mascu-line" position, the 'play' leg is crossed in front of the weighted leg, and the foot of the 'play' leg is resting on the tip of the toe – a position in which the men lean on or rest on something at the same time.

Once again, an example of East German women's politics that re-peatedly makes very clear how much emphasis the men are put-ting on maintain-ing the hierarchy of male/female as part of totally internalized be-havior.

The text reads: Using the tele-phone is not only a matter of the voice, but also of good pos-ture, especially when the phone

booth has glass walls.

In this period when there were scarcely inter-nalized uncon-scious behavior patterns upon which the male/female hierarchy was based, certain body poses such as this one were not yet taboo for women as being "masculine".

Telefonieren ist nicht nur eine An-gelegenheit der Stimme; sondern auch der guten Haltung; vor allem dann, wenn die Telefonzelle Glas-wände hat.

When women place the 'play' foot in front of the other one, they rarely ever rest or lean on anything, and the 'play' foot does not rest on the toes like the men's do. Pic-ture 292 is, how-ever, almost an exception to this.

These are not exactly excep-tions, but rather leg positions that are more similar to women's. Both men are standing with their fists markedly at their pockets or belt, and they are leaning back relaxed on the surrounding objects, as I rare-ly saw in women.

Exception.

Even this "masculine" position used by a woman appears in the male media, "re-defined" as a proffering pose.

297

298

299

300
Actress
Jane Birkin
GneRevue
43/1975

121

have been stored for the past three decades at a women's art archive in Hamburg, I was struck by how different they were from the book: the individual images were much larger, and one become much more aware of their various provenances; the logic of placement was slightly different, more vertical, so that exceptions sat above or below the main rows, rather than floating to one side as in the book; and they were also designed so that they could be hung in the middle of a space, as well as on the walls, so that viewers would be aware of other visitors' bodies behind the panels.

Where, then, is the 'work'? The book of *Let's Take Back Our Space* is more than a catalogue of these original collages —and, in many ways, it exceeds them, both in its scope and its graphic inventiveness. One argument would be that, as with many photographic projects, the book was always its natural form. But perhaps Wex's body of work is best understood within her own understanding of bodies: as something contingent, gendered, political and provisional. In these terms, both the book and the panels are merely the *membra disjecta* of a project of translation, subject to all the laws of parodic resemblance, which aimed at producing a world rather than a work. Translation would, in that case, no longer be a narrowly formal concern, but—*à la* Walter Benjamin—a quasi-theological one.

For Wex, the project was one part of a lifework, a vocation, in the fullest and least fashionable sense. She stopped making art entirely after the book was published, feeling that even her analysis was "based on artistic and scientific methods that have been totally derived from men's interests", and decided instead to, "put all my energies in creating new forms with other women".* To understand her work, across its iterations, involves taking that decision seriously, as a judgment not only on her own work but also on other artworks which we might cherish and in which we might seek her artistic siblings (Martha Rosler, Sanja Ivekovi, Henrik Oleson, etc.). What is living in *Let's Take Back Our Space* is not that set of reassuring coordinates—the possibility of reinscribing Wex into a history of art, or photography, or even feminism—but rather the untranslatable urgency underlying the titular imperative, the promise of difference beyond parody in "new forms", and the limitless claim of love.

MIKE SPERLINGER

*
Marianne Wex, *Let's Take Back Our Space*,
Frauenliteraturverlag Hermine Fees, Hamburg, 1979;
Wex subsequently became a healer and still gives
workshops around the world to small groups
of women, drawing on what she feels she learnt
during the 1970s about the effects of comportment
on women's physical and mental health. I curated
a show at Focal Point Gallery, Southend in 2009
which included some of Wex's original panels.

HARDCOVER

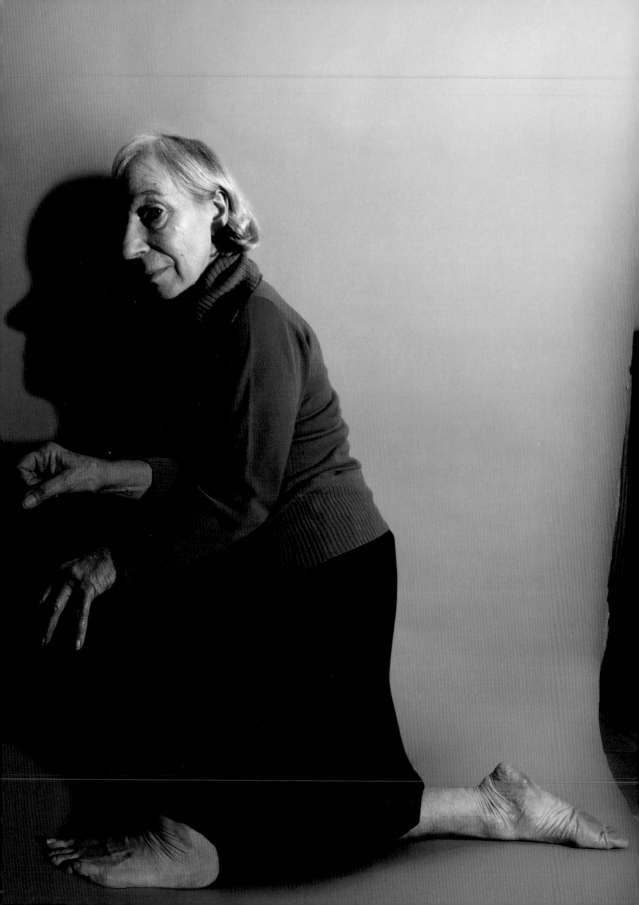

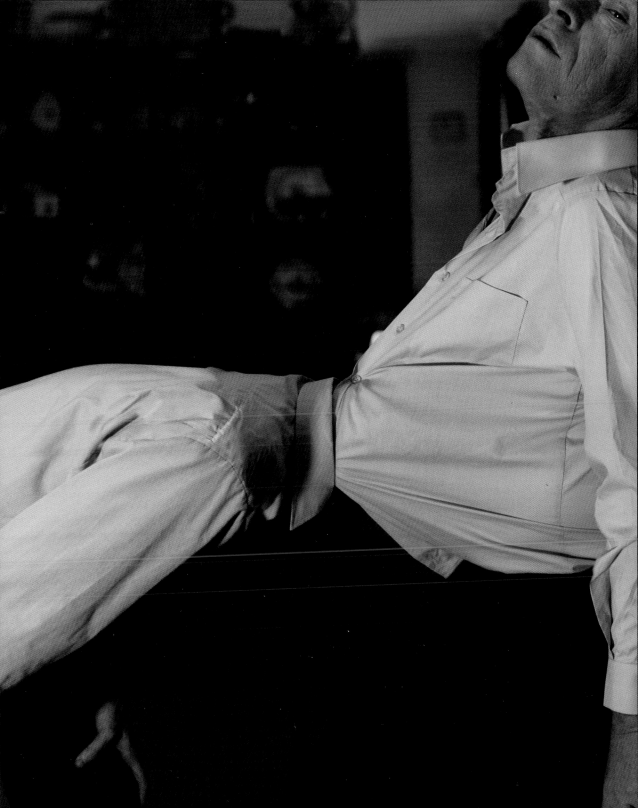

It had been dark for several days now, day turned to night and night to day without there ever appearing to be but brief glimpses of light, flashing momentarily. The skies rolled by furiously, swelling angrily in a strange twilight, crashing in waves that burst into pouring showers. Water ran in tiny rivers, steam rising upon impact.

She had come here almost every day this week—the glass roof amplified the raindrops, comforting in their dramatic overtures. At least the weather seemed to hear her thoughts, the rage and grief. Inside and outside collide here, within this forgotten corner of the city. No one seems to remember it exists. Except for a few lone figures, she had not seen anyone in days. Birds flew in and out of the tipped glass panels along the side wall—only the black blue sky and a blurry grey outline of the city visible through the sweating, dripping glass. The orchids, ferns and palms, with their Latin names on tiny carefully placed signs, bloomed proudly, oblivious to the lack of audience. She slowly sounded out these unfamiliar words, forgetting them as soon as they formed a shape in her mouth.

The air was so thick here it felt solid, acrid, sharing the vegetation's breath. The silent statues, looked on with their artificially dismembered limbs, copies of gods and goddesses from another time.

She seemed to be surrounded by fragmented broken bodies, twisted rotting bodies with pierced and flayed, wounded skins. Stretched out Christs in the hundreds draped the walls of the adjacent museum, gaping mouths, silent cries. She walked past them at a pace, which allowed seeing without registering or stopping. Cranach, Grünewald, pain veiled and unveiled in burnt gold, umber, petrol, the same story told and retold. Walking through these empty rooms to get to the glass house, silent guards sat immobile at every corner as though cast or carved, echoing the bodies they protected.

Presumably this could go on forever, this wandering, the emptiness, the iron taste of apathy that seemed to coat her tongue no matter how raw she scrubbed it, gagging every morning. Perhaps she could just sit on this bench every day until the thunder stopped and the skies closed. She hoped the storms would continue forever, feared the surfacing of day. Her skin felt like paper—perhaps it would dissolve in the rain, like tasteless rice paper, wafers at communion. She knew language would return eventually, remembered the last time, recalled the dragging of feet, the pain along her spine every morning, the flood of dread upon waking. Prior knowledge, this bodily remembering, this physical infidelity in the repetition of mourning, brought no relief. The end of the world. Once again. It seemed ridiculous, such expenditure, such relentless exhaustion, trudging through the steam, slowly lifting one foot, then the other. What was automated just last week, now a complex chain of actions, requiring a will she no longer possessed.

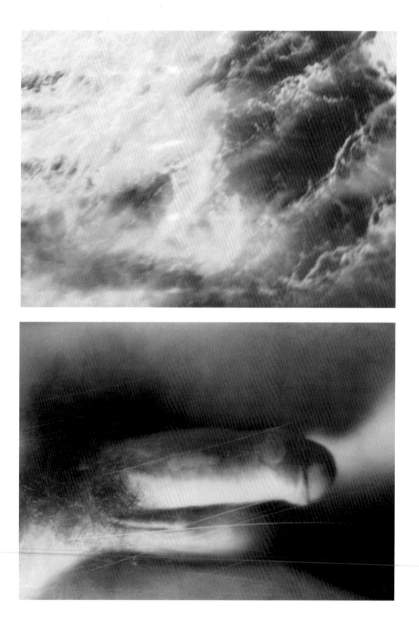

The black of the storms had folded into night and suddenly she realised she had been alone for several hours. A caretaker was locking each section of the glass house, maintaining their different temperatures and humidities. She wondered if she could will her legs to move, wondered if they would bear her weight, allowing her to leave.

Like a knife he is lodged inside me. She had read these words somewhere. Why was it, she wondered suddenly, moving from the sweet wet air of the palm house into the cooler desert night, that each work seemed like the last. Another always inconceivable, yet somehow more words, more images eventually follow the last. Each time they had held one another, entwined in each other's arms, inside one another, each time, she had been equally sure it was the last, and equally sure that this would also mean the end of the world, her world. To die a little more each time, little by little. Like a knife, he is lodged inside me—she formed the words silently within her mouth.

She remembered a girl at school who had stopped speaking. Did not speak for years, simply stopped. She wondered if she was forming these words, reading the Latin signs of plants imported by an emperor in another time from distant lands, simply so that language might not leave her entirely.

Grief took hold anew every day, as though the fall of sleep withdrew all memory, and every day upon waking he died again and she with him. Days spent in saunas, steam rooms, the world disintegrating in water vapour and heat. Here within these other glass houses, she pushed her body further and further, enduring the burning heat, head separating, leaving body behind. This self-induced fainting, this willful drowning, promised the delirium of falling away, of dissolving. She watched the water run down the glass, steam rising from the soil as the rain beat down, the world beyond distorted, slipping away, sliding with every drop. She lay down on the last bench, the final set of heavy glass doors shielded by a curtain of plastic strips. The moist surface of warm wood met her spinning head. Gasping in the thickness, drinking air, she fell into sleep, fell into the night, that other night in which all appears more real than by day. It seemed everything of consequence happened within this night. It was within this darkness that he had found and held her, within this space that language could not reach, where words fell away. It was in this same night, they had beaten another in anguish and frustration, their distorted, exhausted bodies finally overcome by sleep, embracing in sorrow.

TURN

The
breath, a
continuous rhythm of an inhale
followed by an exhale each of us adhere to.
At times we are more conscious of its presence
than others, when it fades into the background,
like a shadow that moves
harmoniously with our body.

The breath, an exchange, an invisible circulation, an ebb and
flow that allows for the continuation of life. Its path provides
a link between internal and external. Like a silken thread it
elegantly weaves its way, stitching body to environment,
reminding us of our dependence on that which envelops us.
External enters internal. Internal reaches to external. It is like
a free spirit, an embodiment of life, freely flowing,
rhythmically playing
between worlds.

The breath, something so discrete but yet which
bares such a heavy burden. Its lightness feels seemingly
un-touched by the weight of responsibility
it holds. But what comes with such a fragile
balance is the profound effect of when it is
broken. An inhale without
an exhale.

An exhale without
breathing
in.

The Unnameable

You are not to speak Her name, and you are not to acknowledge Her presence, for She is always there but She is unnameable. She has risen from the sea with an elephant of ten tusks and seven heads. She has tamed this beast and calls it Her own. You worship Her for Her victory, and fear Her for Her elephant. To welcome Her is to succumb to Her influence. She will surround you and suffocate you. At night, when you are sleeping, She searches for more. More filth and more evil, too much is never enough. She lives in the shadows of all cowards, liars and cheaters. They foolishly think they have tamed Her, that they have channelled Her energy. They take the elephant for a walk when they need to, when it serves them. When it serves Her.

My eyes can't see anything in the dark, but there is an elephant standing somewhere in this room, I am sure. I can hear it breathing. It is telling me everything that we don't remember. Can you hear it? It is telling me what happened here, in this room, in my head, in your head. I don't remember what you forget, but this elephant does and it is telling me things. Why can't we see this elephant, why can't we turn on the light, at least open the curtain. Why do we have to live here, in the dark, staring at the darkness. At each other.

The elephant tells me that everything is important, that what happened yesterday is today. It tells me he has not just appeared in this room, by some magic. This fucking elephant has been living in this room since it was a calf. It has grown up in this room, I have been feeding it. Have you? It has been living, breathing and remembering this room this whole time! I tell you this because the elephant told me, and you don't believe me. You cannot see it so refuse to believe it is here. Ask it yourself! Now I know it is here, it is always standing over me, blocking me out with its shadow. I hope the elephant tramples on you when you are sleeping. Or even when you are awake, there is no difference; your eyes are always closed anyway. Now, the elephant has grown too big to leave through the door. We will be stuck here forever. In the dark. With this elephant that you refuse to hear. And you, you think I have grown boring, spent, but it's not me—it's the elephant.

In secret, he takes freezing cold baths–dipping under and
closing his eyes he likes to imagine he has been thrown into the
Atlantic while lying in a wheelbarrow. As the sea gets colder
and darker, his pores get tighter and his hair harder. Soon his
skin pulls taut across his bones and the water starts to freeze
his nose and throat. His body shrinks under the pressure, he
feels tiny and beautiful. Something hard and shiny slips over
his neck. It is a gloved hand, and a voice begins to talk to him.
She is telling him that the elephant is looking for him, and he
grows unhappy. The elephant thinks he has tried to escape, She
says. He says he hasn't tried to escape he *has* escaped. No he
hasn't, She says. No he hasn't, says the elephant.

> Now, this room, it is a lift of glass and metal. The elephant has
> grown so fat and heavy it is starting to pull us downwards, and I am
> looking out the window, at the black blue sea, frothing, whirling
> and throwing itself violently over black round rocks. If we were in
> the sea, we would die. Suddenly, the wind and storm gets worse.
> The lift is thrown into the sea, and as the first corner hits we begin
> to be submerged. If the glass hits a rock the lift will flood and we
> will drown. It is dark, blue, suffocating and cold. We could try to
> escape but we are probably safer inside the lift. Soon we hit the
> ocean floor, me, you and the elephant. I have taken you with me.

The lift sparks off a rock and lights up the shapeless sea and the
black lift. As the spark dies, he finally sees the elephant, with
its ten tusks and seven heads, and he sees Her standing beside
it, controlling it. He wishes he hadn't fed it for so long, but it is
not up to him now, it is up to Her.

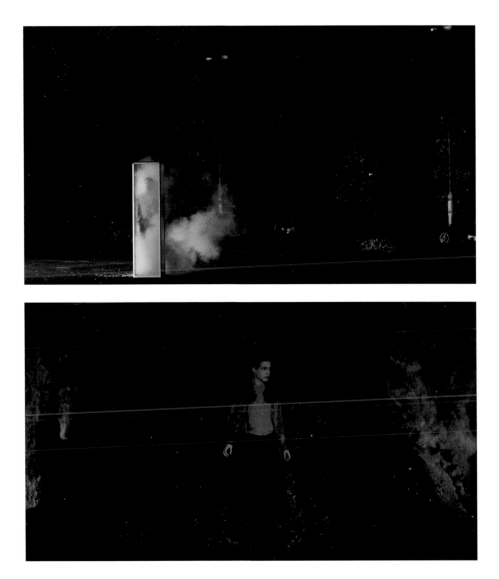

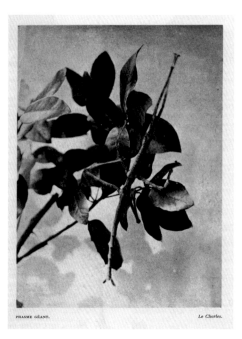

PHASME GÉANT. Le Charles.

MIMETISM
AND
THE MOUTH

Olivier Richon

In *Minotaure 7, 1935*, the Surrealist journal that took as its emblem a bull's head on a human body, Roger Caillois publishes his first texts on mimicry. It begins with a warning: *Beware, if you play at being a ghost, you may become one.*

It is illustrated by photographs that are taken by Le Charles. They are pictures of plants and of insects looking like leaves and shrubs. These Documents, with a capital D, are formal images that recall plates from natural history books. They could have been taken in a studio, I do not know. The stillness of the insects makes them a perfect subject for photography. They are complicit with the photographic act. Yet are these insects at home in their habitat? They look as if their near invisibility protects them from predators. Or are they themselves predators, waiting to pounce on their prey? Insects are not alone in this art of dissimulation.

By retracting its tentacles the octopus, because of its grey colour, can resemble a stone.

Caillois tells us that morphological and chromatic mimetism are linked to photography. The insect turns itself into a photograph. Even better, it is a photograph in three dimensions, a photograph-sculpture. This is why these images by Le Charles are so fascinating: they are photographs of insects that behave like photographs. They are pictures of animals that act as if they were a picture, and a picture hidden within a picture. But what is mimicry for? Do these insects benefit from their dissimulation? Caillois' answer is negative. Predators mainly use their sense of smell rather than sight; they devour these insects irrespectively from their ability to mimic their surroundings, even if these insects are invisible to the human eye. Resemblance does not keep them alive.

MIMETISM AND THE MOUTH

A better defence than resemblance is stillness: to be as still as an image, to keep still, as if posing for a photograph. Some insects even use a falsely rigid position and resemble a corpse in order to avoid being attacked. Caillois concludes that mimetism does not protect against predators. If this was not bad enough, mimicry has another disastrous consequence: insects of the same species become confused by their own mimetism. Because the *Phillies Biocaltum* can resemble leaves to perfection, they mistakenly end up munching one another. "Is this collective masochism?" asks Caillois, or is this a manifestation of an unintentional and uncontrollable form of cannibalism?

This leads Caillois to compare the biological and the psychological. Is there a connection between the insect's mimetic behaviour and human psychastenia: anxiety, obsession, doubt, phobia, inhibition? And are some of us that different from these *Phillies Biocaltum* in our relation to space? This points to a troubling relation with space, where we do not know how to place ourselves. The boundaries between me and not me are unclear. I know where I am but I do not feel myself at the place where I am. Space pursues me, envelops me, devours me and digests me, until I am totally assimilated. Caillois quotes *Flaubert's Temptation of Saint Antony*, a novel partly inspired by Brueghel's painting of the same name. Flaubert's version has the hermit succumbing to a general mimetism with his surroundings:

> Vegetable and animal can now no longer be distinguished. Polyparies looking like Sycamores have arms on their boughs. Antony thinks he sees a caterpillar between two leaves; but a butterfly takes off. He is about to step on a pebble; a grey grasshopper leaps up. Insects resembling rose-petals adorn a bush; the remains of may-flies form a snowy layer on the ground.
>
> And then the plants become confused with the rocks. Stones are similar to brains, stalactites to nipples, iron flowers to tapestries ornate with figures. In fragments of ice he perceives efflorescences, imprints of shrubs and shells—so that he hardly knows whether these are the imprints of the things, or the things themselves. Diamonds gleam like eyes, minerals pulsate.

OLIVIER RICHON

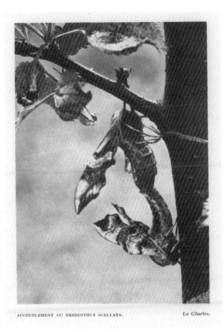

ACCOUPLEMENT DU SMERINTHUS OCELLATA. Le Charles.

HARDCOVER

MIMETISM AND THE MOUTH

PHYLLIE-CONTRACTURE HYSTÉRIQUE CHEZ LA PHYLLIE.
Le Charles.

OLIVIER RICHON

Saint Antony is frozen in a cataleptic pose, like a photograph, and like these insects that maintain a rigid corpse-like posture: a frozen monumentality, a statue-like immobility that is also found in acute cases of schizophrenia. Yet he is enjoying this ecstatic dissolution.

Mimetic life is all about eating and being eaten, assimilating and being assimilated. Catalepsy is the insect's death drive and our own. This brings us to Roger Caillois's early writing on the *Mante Religieuse* or Praying Mantis that appeared a year earlier in *Minotaure 5*. The female Praying Mantis, by eating the male during the sexual act, appears to combines sexual and nutritious pleasures. Yet does she eat the male because of hunger? Is this a reality principle based upon a biological need? Not quite so Caillois tells us. The spasms of her decapitated companion improve the sexual act. After all, it is the pleasure principle, combining the oral and the genital, that commands the execution and digestion of her lover. Not surprisingly, scientific studies of the Praying Mantis, follow the style of lyrical objectivity, praising the insect's perfect mechanism that appears to be functioning automatically, like the famous beast machines of Descartes. The Praying Mantis has a close connection to the power of the gaze. She is the only insect that can turn its head and follow others with her eyes without moving the rest of its body. With joined and bent front legs, she has the appearance of a devout praying. Caillois' study of the Praying Mantis is contemporary with Dali's research of Jean François Millet's painting *The Angelus* (1857–1859). This small but highly popular painting shows a peasant couple praying at the end of the day, standing up and motionless in a potato field. For Dali, the atavistic twilight of the scene announces a sexual and cannibalistic drama. There may even be a corpse in this potato field, the corpse of their dead child. Dali takes it upon himself "to avenge Millet's *Angelus* from a long and shameful repression". The painting's religiosity and moral values only thinly disguise its underlying sexuality.

The peasant woman recalls the Praying Mantis, in a murderous cataleptic pose of devotion. She is the sewing machine preparing an encounter with the umbrella, that is with the man who is praying, respectfully holding his hat in front of his groin, and thus concealing the bulge of his

MIMETISM AND THE MOUTH

shameful emotion. Writing about Dali's work in 1929, Breton suggests that the frame of his paintings is a wide open mouth that interpellates the viewer. We are sucked into this aperture; we are the picture's prey. The picture is an alluring conceit that seduces the viewer in the same way as the tongue of the anteater seduces the ants that cannot help but go towards it. Dali's tongue is a tongue that eats and a tongue that speaks, uttering paranoid—critical meanings. As the philosopher Alain Grosrichard suggests, for Dali the unconscious is structured like an anteater's tongue, as viscous as Freud's libido. For Breton, the aesthetic emotion is a spasm. In *Minotaure 5* he writes: "Beauty will be convulsive or it will not be." To which Dali adds: "Beauty will be edible or it will not be."

OLIVIER RICHON

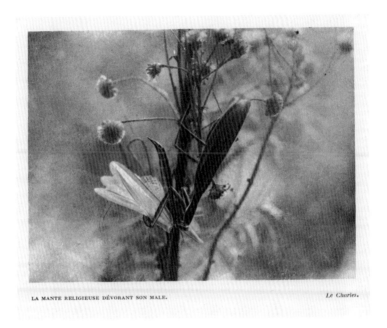

LA MANTE RELIGIEUSE DÉVORANT SON MALE. *Le Charles.*

HARDCOVER

FIRE AT THE LIMITS/ AGAINST THE LANDSCAPE

Simon Baker

A day will come when a single crack will nick this 'landscape'
which is uniformly covered over with expressionless smoothness,
and a fissure will gradually deepen until this 'landscape' is completely
turned inside out like a glove being taken off. There will undoubtedly
be a revolt…. Fire will engulf the entire surface of the city….
Takuma Nakahira, 1970[1]

Writing about the relationship between photography, perception and what is referred to as "urban rebellion", in 1970, following two years of political upheaval on the streets of Tokyo, the photographer Takuma Nakahira proposes a series of challenges, all of which, it seems, are meant to leave the word 'landscape' open to question, and many of which invoke an apocalyptic imagery of fire and flame. Trying to remember, and to picture, recent riots in Shinjuku and Kamata, Nakahira asks himself

> *Why do I always imagine a fire? And why night?…*
> *the world only appears before my eyes as a solid*
> *'landscape', lustrous like plastic. While this does not*
> *bode well for my body and my senses, I could also say*
> *that it is precisely for this reason that I continue to take*
> *photographs….*[2]

Nakahira's evocation of a lustrous plastic 'landscape' which, he says, "the city cannot exist without", suggests a deep and complex relationship between the urban environment, the politics of protest, and the ability of the photographer to make the real world live up to its imaginary or imagined

SIMON BAKER

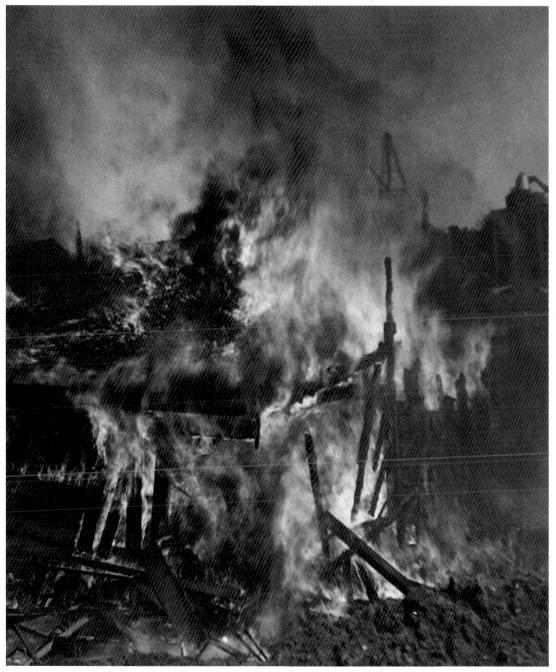

potential. Perhaps unsurprisingly for a member of the avant-garde Provoke group, (whose other photographer-members included Daido Moriyama and Yutaka Takanashi), Nakahira sees the everyday violence and disorder of the city as part of a conceptual 'landscape' that is always in question; always at odds with itself.[3] And as if to emphasise the conflicted nature (and limitless potential) of the city, the subject of not only his own work but that of his colleagues Moriyama and Takanashi, Nakahira suggests that a sacrificial poetic contradiction is inherent to the nature of the urban imaginary. At night he says, the city acquires a flawless and impregnable beauty, which the photographer has a duty to address: "I must set this 'landscape' confronting me aflame with my own hands", he says; "[with] a fire all my own; this fire is the final shape that my unshakable sentiments can take. Thereafter all that remains is the problem of methodological tactics…".

As such, Nakahira describes the real life of the city, beneath its plastic appearance of (nocturnal) tranquillity, as that which the photographer is obliged to unravel or unwrap. It is, perhaps strangely fitting then, that Nakahira relates the student barricades, (of both Paris and Tokyo), to the conceptual art of Christo, each in turn he says; "blockading and wrapping the 'landscape' up in order to cut into it and blast it apart".[4] Although he admits that "for the time being, there is no other method" available than "to ceaselessly gaze at this 'landscape'",the implicit, umbilical connection proposed between seeing and doing takes the photographer's gaze straight into and through the infernal fire of urban rebellion in what he calls "an unlimited personal act of aggression against the 'landscape'".

Admittedly there is something deeply seductive about the triangular formulation of photography, fire and the landscape: all the more so at a moment of when, once again, (or as ever, perhaps,) urban political upheaval throws down the gauntlet to photography to rise above the conventions of documentary form. But what seems most pertinent in Nakahira's admittedly idiosyncratic approach to what he refuses properly to designate as landscape, (continually leaving it up in the air as 'landscape'), is his emphasis on the dramatisation of the relationship between landscape and politics through photography; characterised analogously with reference to fire.

SIMON BAKER

Among the most subtle, and yet trenchantly political photographers to emerge from the New Topographics group in the United States in the 1970s, Lewis Baltz would seem to have little in common with the Tokyo *provocateur* Takuma Nakahira, beyond, perhaps, a determined sense of the existence of a politics of 'landscape' as such.[5] In Baltz's work, from the oblique minimalism of his early *Prototypes* (made in the late 60s), to the restrained formal complexity of series like *New Industrial Parks* in the 70s, urban and suburban landscapes appear to conform entirely to the mannered obedience of post-war rationalism, while at the same time revealing the unintended consequences of their construction and development.[6] And yet, through his participation in a publishing project called *Landscape: Theory* in 1980, (which includes a murky yard-fire in Prospector Park), and his subsequent production of the seven-part 1986 series *Continuous Fire Polar Circle*, there exists, nonetheless, an alibi for returning to the incendiary third term in Nakahira's triangular constellation.[7]

On the evidence of his writings, and in stark contrast to Nakahira, photography for Baltz is nothing to do with the revolutionary poetry of urban experience (the urgent and romantic drive to set the world alight and burn away the tranquillity of appearances): for Baltz, by contrast, the camera is obliged to register reality with a ceaseless, unblinking, excoriating stare. Despite describing his work as "neither pictorial nor non-pictorial", however, Baltz's photographic subjects are always, inevitably, as he puts it, "self-structured".[8] In the sense, then, of admitting to the value of photographic vigilance, Baltz and Nakahira have something in common, even if their modes of visual and textual expression follow alternate paths. Describing a development around Park City, California, Baltz writes:

> *Other than in photographs and films of natural catastrophes or man-made disasters, I had never before seen a landscape that was as bleak, and, at least superficially, so chaotic. Much of the land looked devastated and exposed: pocked, churned, littered with fragments of metal, wood, glass and wire, it supported only meagre, stunted vegetation. This appearance of*

'matter out of place' was only partially attributable to the usual dislocations of construction; even the land which had escaped development looked preternaturally silent and lifeless. The place looked like the aftermath of purposeless violence....[9]

Behind the expressionless facade of the American dream of unbridled expansion, Baltz finds everything, (even matter itself), "out of place"; and landscape, or at least our expectations of landscape, "turned inside out like a glove", (to steal one of Nakahira's finer phrases). Concluding that nature is, after all, "fundamentally alien and non-human", Baltz resigns himself to the realisation that, in his words, "what is modern about this is the surprising ease with which we have come to regard the human and the non-human equally".[10]

What Baltz and Nakahira share in their attention to the limits of representation in their work—of landscape, "landscape" and the limits of photography *per se*—is an understanding of its impossible, dialectical character: a philosophical problem that might be understood symbolically in relation to the categorical violence involved in the representation of fire—a photographic subject that will always register, indexically, the limits of indexicality itself. It is no surprise, either, that still, many years after the expansion of the photographic field called for by avant-garde optimists like László Moholy-Nagy, (the terminal drive to register the microscopic, the fleeting, the invisible and the internal, with lenses, contraptions, machines and X-rays), it is still fire, a timeless symbol of sacrificial destruction, that continues to signify (at one and the same time) both the threshold of the rational, and its imminent collapse. The photographs in Baltz's series *Continuous Fire Polar Circle,* are a case in point, existing at the very edge of the camera's competence, and yet seeming to point, repeatedly, to the "surprising ease" with which even this least human of elements can be framed, through the process of representation, into the subject of a picture. In *Continuous Fire*, (although this is true of many equivalent alternatives), photographs of burning materials enter into their own language of irreversible abstraction, where matter registers as matter even as it is expended, exhausted and blown away. This most ephemeral

SIMON BAKER

of subjects, then, which embodies the most fugitive and singular relationship to form, gives a perpetual lie to the camera's bankrupt claim to the whole truth. And yet, what, it is important to ask, might it mean to think of *Continuous Fire* in the terms that Baltz had used in his own writing just a few years earlier: in what sense can fire be, as he puts it "self-structured" as a photographic subject?

One answer, undoubtedly, lies in the serial nature of *Continuous Fire*—its status as an integral sequence in the context of which any individual image has only a fragmentary status. Baltz is very clear about this in his essay in *Landscape: Theory*, stating that, "[his] solution to the problem of the veracity of photographs is to make the series, not the single image, the unit of work".[11] But even the title *Continuous Fire* points to the disjuncture between the process of burning, (which takes place, apparently, over an undefined, but sequential passage of time), and the inadequacy of its photographic traces. Fire is a strange exception to this rule, however, as it would be true to say that just as any individual image fails adequately to depict the subject, producing a series of (inevitably similar) images would repeat, rather than resolve, the problem.

An alternative reading of the situation, however, is also available. If we return, for a minute, to Nakahira's failed attempt to remember the riots in Tokyo; "Why do I always imagine a fire?" he says, "And why night? The world only appears before my eyes as a solid 'landscape', lustrous like plastic.… I could also say that it is precisely for this reason that I continue to take photographs.…" In this account neither the imaginary recollection, nor the visual appearance of the world is accurate or acceptable: neither "landscape" really exists. But for Nakahira this double failure leads back to photography, (compulsively perhaps), rather than away from it, just as for Baltz, *Continuous Fire,* an impossible photographic subject, exists as a series.

In another, better known, serial account of arrested images of combustion, Ed Ruscha's 1964 photo-book *Various Small Fires and Milk*, the category of fire itself falls prey to the logic of catalogue absurdism: a gas hob, woman smoking a cigarette, propane burner, zippo lighter, and other various 'small fires' that bear little physical relation to one another,

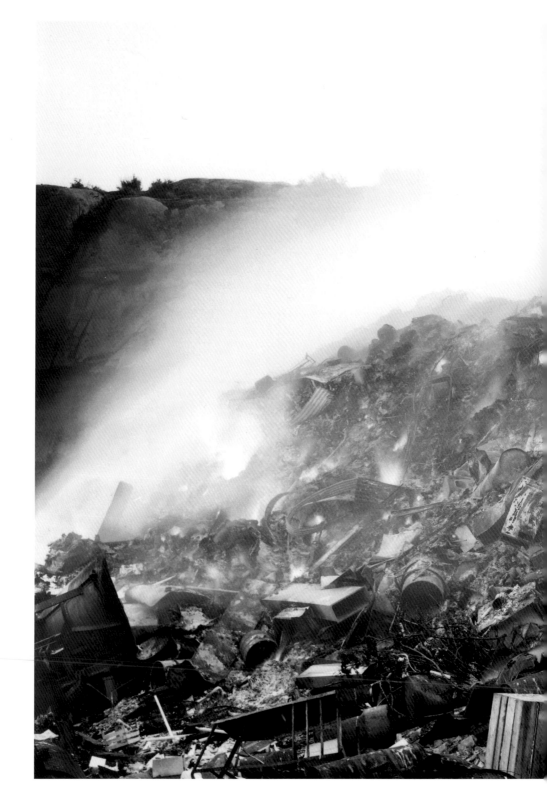

084

are terminated in sequence by a glass of milk at a dinner setting. The failure of the category to even attempt to hang together, (unhinged by milk), seems to bear critically on the solipsistic idea of serial experimentation in conceptual practice.[12] But Baltz's *Continuous Fire* is far from a conceptual conceit, and, given the nature of his practice as a whole, it is impossible to read it as some kind of semiotic ploy against the logic of photography's denotational competence. Instead, it should be seen in the context of Baltz's serial landscape practices of the late 1980s; works like *San Quentin Point*, 1986, and *Fos Secteur 80*, 1987.[13] In these important multi-part works, and in the subsequent larger work *Candlestick Point*, 1989, Baltz seems less interested in the formal potential and significance of architectural structures in the landscape than in an entropic aesthetics of abandonment, collapse, and decay: "matter out of place" as he puts it. The landscapes of these marginal sites on the fringes of Californian suburbs, are prey everywhere to the vicissitudes of Baltz's critical perspective, carefully juxtaposing piles of rubble with finished construction, and cracked earth with tarmac: patches of grass are littered with trash and other physical traces of human activity until the "landscape" (such as it is) seems to fall to pieces, completely out of kilter with itself.

This photographic "landscape", a serial abstraction of the real world produced by the pressure of representation, is one that makes sense, that comes into focus, in relation to the ideal but impossible photograph of (continuous) fire: a concept or image of landscape that is always already, *a priori*, subject to most radical instability, and cannot be accounted for in a single image: where entropy precedes development, so that what can be retrieved, or salvaged from its chaotic state must always be equivalently picturesque and non-picturesque, pictorial and non-pictorial, in equal measure. What Baltz's *Continuous Fire* has to tell us about photography, is what photography has to tell us about the landscape: that it will not submit easily or comfortably to the process of depiction, and that it may never settle even into a series, but that this resolute failure to conform is, to paraphrase Nakahira, precisely the reason to continue to take photographs.

Finally, however, it is to Werner Herzog, that veteran of so many attempts to force the landscape to submit to the

SIMON BAKER

camera, (and *vice-versa*), that the last words belong, taken from his diary of the making of his film *Fitzcarraldo*, *Conquest of the Useless*: "Gather words, my friend, but no one will ever succeed in describing fire exhaustively."[14]

1

Nakahira, T, "Rebellion Against the Landscape: Fire at the Limits of my Perpetual Gazing…." trans., Prichard, FK, in Takuma Nakahira, *For a Language to Come*, new edition with an introduction by Yasumi Akihito, Tokyo: Osiris Press: 2010, p. 9.

2

For a Language to Come, p. 8.

3

For more on the Provoke movement, see Parr, M and Badger, G, *The Photobook: A History*, volume 1, London: Phaidon, 2004; see Kaneyeko R and Vartarian I, *Japanese Photobooks of the 1960s and 1970s*, New York: Aperture, 2009; the "books on books" facsimile edition Yutaka Takanashi, *Toshi-e (Towards the City)*, New York: Errata, 2010; and Yutaka Takanashi, *Photography 1965–74*, Berlin: Only Photography, 2010.

4

Nakahira, *For a Language to Come*, p. 10.

5

See Salvesen, B, *New Topographics*, Tucson: CCP/Steidl, 2009.

6

See *Lewis Baltz: The Prototype Works*, Art Institute of Chicago/Steidl, 2010.

7

Adam, R, et al, *Landscape: Theory*, New York: Lustrum Press, 1980. I am grateful to Walead Beshty for his insight into the importance of Baltz's essay in this book.

8

Landscape: Theory, p. 25.

9

Landscape: Theory, p. 25.

10

Landscape: Theory, p. 29.

11

Landscape: Theory, p. 26.

12

In a similar way perhaps to the photographer Boris Mikhailov's work *Red*, of which he has said (in conversation with the author), "in every photograph in the series there is something red; unless there isn't".

13

For more on Baltz's work, see either, *Lewis Baltz: Works*, Göttingen: Steidl, 2010; or *Lewis Baltz: Rule Without Exception*, University of New Mexico, 1991.

14

Herzog, W, *Conquest of the Useless*, trans, K, Winston, New York: Ecco, 2009.

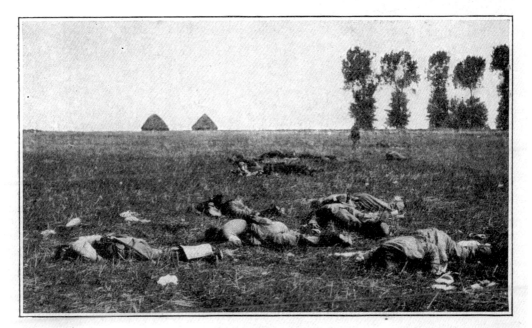

AFTER A BATTLE.
Dead soldiers left on the battlefield after a charge.

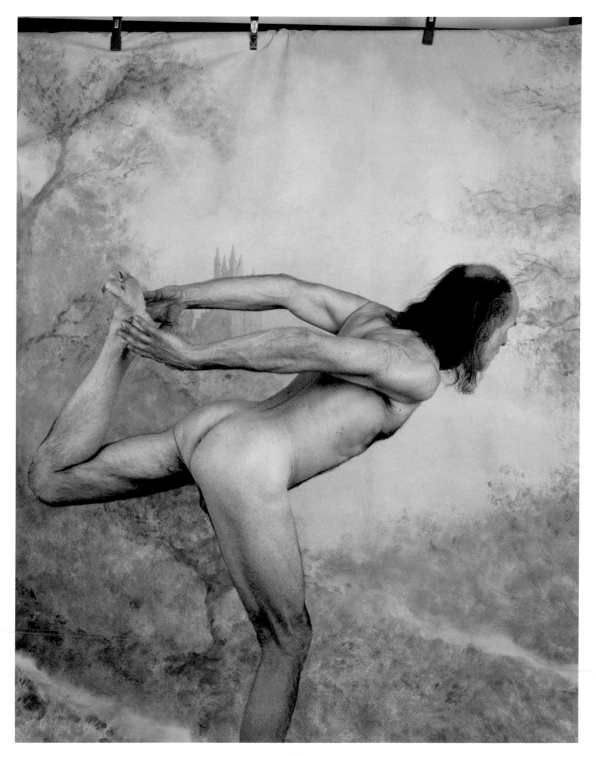

Sail

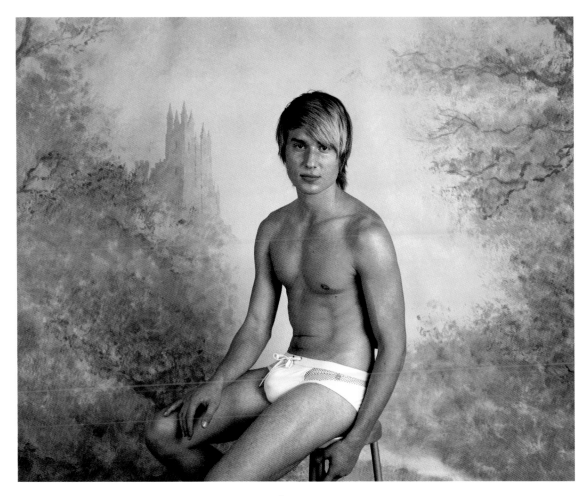

Spencer

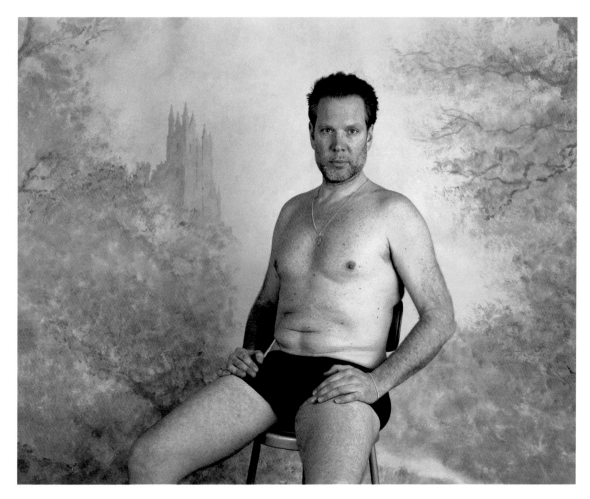

Ivan

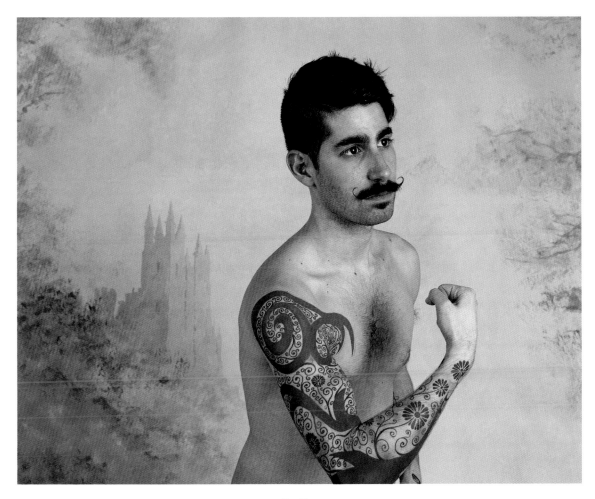

Pacifico

Something in the smell of the wood, the familiarity that makes no sense,
the feeling of home

no question that it feels like home,
this house, in this country, this language I don't understand,

where I feel free, free because I don't choose to understand if people
stare

for it doesn't matter in this country that is not my home
I feel at home as a foreigner in this place I do not belong
because no-one questions my belonging

and I don't belong
except to the feeling of belonging that this place brings

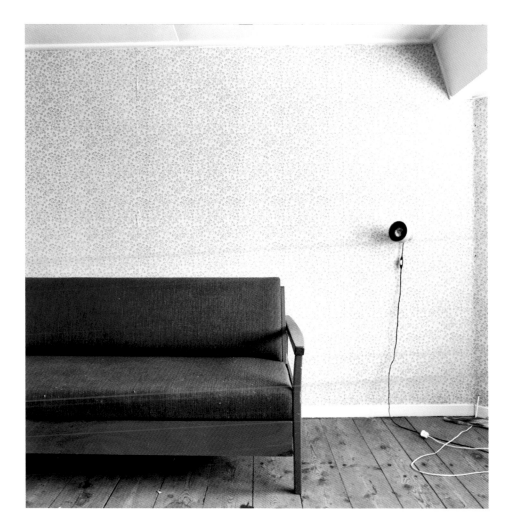

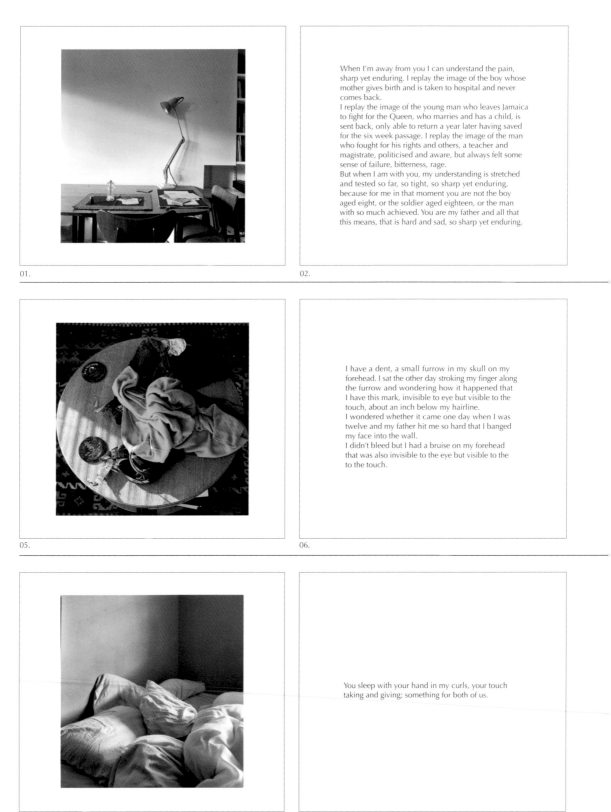

01.

When I'm away from you I can understand the pain, sharp yet enduring. I replay the image of the boy whose mother gives birth and is taken to hospital and never comes back.
I replay the image of the young man who leaves Jamaica to fight for the Queen, who marries and has a child, is sent back, only able to return a year later having saved for the six week passage. I replay the image of the man who fought for his rights and others, a teacher and magistrate, politicised and aware, but always felt some sense of failure, bitterness, rage.
But when I am with you, my understanding is stretched and tested so far, so tight, so sharp yet enduring, because for me in that moment you are not the boy aged eight, or the soldier aged eighteen, or the man with so much achieved. You are my father and all that this means, that is hard and sad, so sharp yet enduring.

02.

05.

I have a dent, a small furrow in my skull on my forehead. I sat the other day stroking my finger along the furrow and wondering how it happened that I have this mark, invisible to eye but visible to the touch, about an inch below my hairline.
I wondered whether it came one day when I was twelve and my father hit me so hard that I banged my face into the wall.
I didn't bleed but I had a bruise on my forehead that was also invisible to the eye but visible to the to the touch.

06.

09.

You sleep with your hand in my curls, your touch taking and giving; something for both of us.

10.

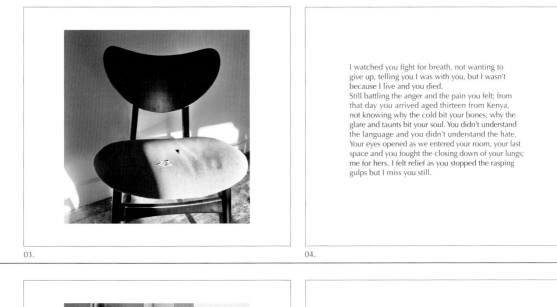

03.

I watched you fight for breath, not wanting to give up, telling you I was with you, but I wasn't because I live and you died.
Still battling the anger and the pain you felt; from that day you arrived aged thirteen from Kenya, not knowing why the cold bit your bones, why the glare and taunts bit your soul. You didn't understand the language and you didn't understand the hate. Your eyes opened as we entered your room, your last space and you fought the closing down of your lungs; me for hers. I felt relief as you stopped the rasping gulps but I miss you still.

04.

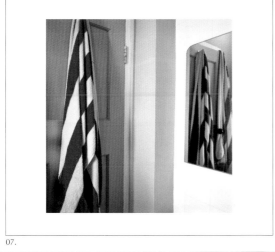

07.

I don't surround myself with people who say those things, think those things, not anymore.
I thought – who are you?

08.

11.

12.

From the slide show *Fabric*, 2010

THE NARCISSISM OF SMALL DIFFERENCES

Leslie Dick

Where are the depths concealed? On the surface.
Hugo von Hoffmansthal

Women are considered profound.
Why? Because one never fathoms their depths.
Women aren't even shallow.
Friedrich Nietzsche

The more alike things are, the more significant the differences between them become, however slight. These minor differences, slight like a paper cut, not incapacitating, not even debilitating, more a distraction, peripheral, inconspicuous, these often tiny, insubstantial marks of difference become the site of passionate identification. We find ourselves in the detail, we distinguish, we express our preference.

The pattern lies on the surface, repetitive, and with each repeat, differences emerge. Are these differences mistakes? How does the flaw, the inevitable imperfection, register? Maybe there's something to these errors, the slip of the tongue, or the brush. Someone says, somewhere, that it is in the slip of the tongue that we find our true voice. In the rough edge, the margin of error, something else comes through, as if from another dimension: a mark of distinction, a shadow, or a sense of elsewhere.

But repetition is practice, and practice makes perfect. Surely, if I do it over and over again, I will get better at it. What does it mean if I don't? That there is no room for improvement? That I am already a master? Or am I proved incompetent, is this inability to improve mere evidence of my falling short?

Personally, I never like doing things I'm not already good at; I only enjoy in an unadulterated fashion doing things that I know I can do already. As a result, learning

LESLIE DICK

something new really takes a lot out of me. It drains the narcissism out of me, I feel humiliated, but more than that, it's as if I don't know who I am, what I might become, when I begin to do something I can't already do, or do well. Or perhaps I shouldn't say "do well", but to my own satisfaction. Well enough, perhaps that's the best term. There's no objectivity here, only my own harsh judgement. I know I am very good at some things, but I can't hold them in my mind for more than a moment. In any case, it's true that I only really enjoy doing things I'm already good at, and as I am hypercritical, my activities are as a result somewhat restricted. My partner in life, however, has a much longer list of things he doesn't do, and won't try to do: he doesn't drive, or swim, or sing, or shout. By contrast, I do all those things, quite well, or well enough. I am particularly good at driving and shouting.

When asked to define "the narcissism of small differences", I can only resort to outdated structures of political affiliation, the perfect example of identification articulated through rivalry. Traditionally, one tiny Trotskyist splinter group hates and loathes and battles furiously and perpetually with another tiny Trotskyist splinter group, lavishing more attention and resources on this adversarial differentiation than on the larger struggle against capitalism. It is an opposition located in almost invisible details, the vehemence of their justification utterly mysterious to even the most sympathetic outsider.

Yet these hypothetical splinter groups would seem to be a thing of the past, a social formation of the years before 1989, and possibly a more contemporary (and non-European) example would point to the struggles between fundamentalist religious groups, or maybe even groups of skateboard enthusiasts, in order to demonstrate the historical persistence of this phenomenon. We continue to care so much.

To repeat myself, it seems to be the case that we find ourselves in the small differences, as if details in themselves serve to mirror our most insistent characteristics. The small differences become more and more critical, as we labour under the injunction, thou shalt be unique. We are obliged to differentiate ourselves, yet simultaneously we are under a counter obligation to be similar, recognisable, one thing or another. The primary designation is one of gender: we must be

THE NARCISSISM OF SMALL DIFFERENCES

instantly locatable on one side or the other of the great divide. As we become involved with one another, we tell and retell anecdotes about ourselves, to trace the specificity of our very own historical trajectory. We collect objects, artworks, clothes, shoes, in a desperate attempt to distinguish ourselves from our group: my 1950s lamp is fabulous, and very slightly different from your fabulous 1950s lamp. Life becomes a display of choices; we show them off (my car, my jacket, my new Puma sneakers) in order to register a unique (yet recognisable) personality.

I was over 40 when I willingly chose to begin to try to do something I didn't know how to do; I hadn't had to do something like that since I'd been at school, some decades before, and I'd never really bothered, even in school, to try to be good at things I wasn't already good at. I found out that I became enraged when I couldn't do it right away; it made me nutty, I had no patience for it. I found out that if you do something over and over again, you can become better at it. I also found out that I had a very limited tolerance for that kind of repetition; I could say that it bored me, but I think it was more than that. I didn't know who I was when I was trying to do something that I couldn't already do.

Narcissism is about surface, and image, depending as it does on the structure of the mirror. We are locked in a visual structure within which an illusory (reversed, symmetrical) self is fixed, like a photo is fixed in the chemical bath. We fix ourselves, in the image, we are outlined, repaired, and stuck. In the mirror image, the mirage, we see only surface details, and it is as if each detail holds the key to who we really are. The frame and symmetry of the image holds us together, keeps me hanging on. Putting on my eyeliner, applying my red lipstick, I think, it is in the small differences, the little mistakes, that we find ourselves.

But in this system of differences, what form would a mistake take? Details delineate differences, yet these differences can only be designated mistakes within a structure of antagonism, a scene of judgement. Maybe there aren't any mistakes? In which case, how could one decide which one is better? Yves Klein once made an exhibition of identical blue paintings, each exactly the same size, and then sold them for drastically different prices, based on the different quantities of

102

LESLIE DICK

'spiritual value' with which the artist had imbued each painting.

In the car, driving through the city, my shiny exterior slides by all the other exteriors; I know there is depth there, but I can't see it; I see only a series of surfaces, patterned, variegated, and I ignore what I can't see. We slide by each other, surfaces, like outlines of ourselves, upright, vertically orientated, and on occasion, my facade faces your facade, like the encounter between two pictures, cutouts. But "deep" is supposed to mean good and meaningful, while the surface, "superficial", is on the side of bad and meaningless. The surface, the deceitful surface, is on the side of femininity, decoration, and masquerade. And make up, something that takes place, takes time, over and over again.

Like meaningless repetition, decorative patterns form repeats. They are symmetrical, geometric, anonymous. They connect us to an elsewhere, another place where similar patterns are repeated, over and over. With their insistent repetitions, decorative patterns demonstrate their superficiality; they are not original, they lack the authority of the unique. They repeat their mistakes, and they resist valuation, at the same time as they resist improvement. Which one is better, which one best? These patterns repeat themselves, and maybe that's a bad thing.

Identity is by definition repetitive, as I wake up morning after morning, look in the mirror, and proceed to move through each day, continuing somehow to be like myself. Only occasionally surprising myself, most of what I do is unsurprising, recognisable: it's done over and over again. My rather restricted activities, my amorous proclivities, my stylistic tendencies are sustained and represented by my look, my characteristic gestures, my limited, yet wildly idiosyncratic vocabulary. It's a matter of emphasis, where (in the repeat) the emphasis falls. This maintenance work, like the fixed image, holds me together, lets everyone know what I'm about. When it breaks down, at the edge, the margin of error, where the registration slips, something else comes through, as if from another dimension: a shadow, a sense of elsewhere.

For Renée Petropoulos

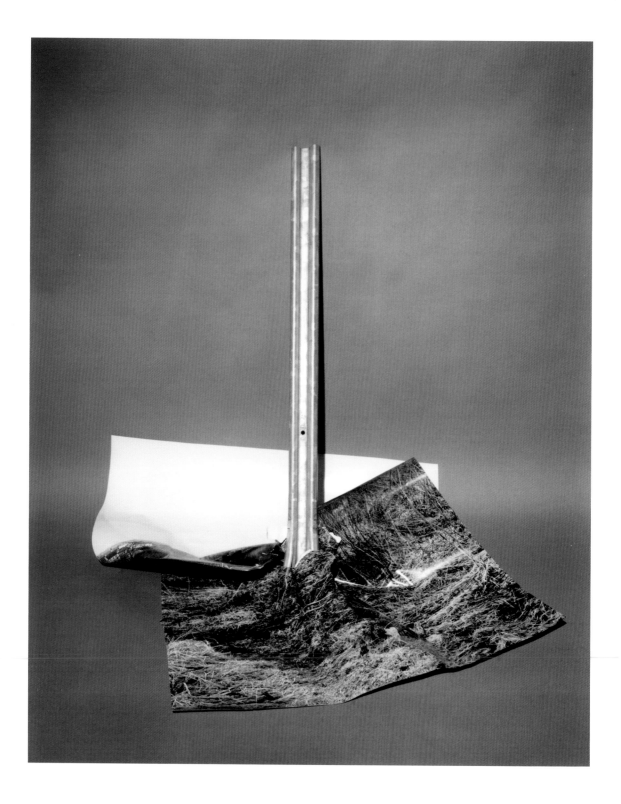

Dear Mr Mark McGeever,

I understand you are a freelance professional political speechwriter. I am contacting you to ask if you may be able to respond and reconstruct a political speech that addresses the subjects and concerns outlined in the speech I have written. (See attached document.)

I look forward to your response.

Kind regards

Rebecca Court

Rebecca Court

Language and Power

The issues of power, control and choice that are currently confronting us in our political system have led to widespread action, gestures, protest and events. But do we really have an awareness of the mechanisms of power that frame the everyday lives of individuals; our movements, our choices, our liberties? What is this power, how is it acquired and exercised?

Do we have any leverage as individuals within the current system and structures that conceal the mechanisms of knowledge that lead to increased power? Is it the case that the present political-economic situation has fuelled an impulse amongst people to resist or challenge the decisions that are made on our behalf?

I wish to address the limitations in the individual's ability to activate themselves in relation to the politically manipulated frameworks of power that are put in place.

The economic situation of unpopular government funding cuts; the implications this will have on the poorest members of society and the limiting of opportunity for future generations are some of the most pressing matters in this country.

For many individuals what once may have been described as apathy has turned into anger. A movement that has seen an awakening of the social individual; a passive receiver of government politics, now turning into an empowered campaigner for change through a sharing of concerns with others.

But I ask you to consider what it may mean for society if voices are not heard and if power from 'above' is constantly enforced.

In order for such systems of power to be broken down, they must be exposed to reveal what they aim to conceal. The information fed down to us must be placed under sever scrutiny. I ask you to re-question and address your position as an individual amongst the systems that we operate within. Only by reassessing our position within society can such overwhelmingly controlling structures really be challenged.

Rebecca Court

Language and Power

Written by Mark McGeever
(Political Speechwriter)

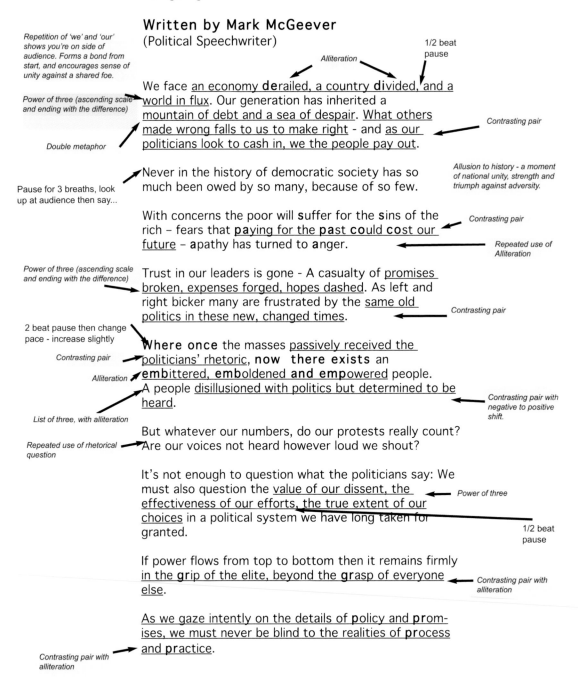

We face an economy derailed, a country divided, and a world in flux. Our generation has inherited a mountain of debt and a sea of despair. What others made wrong falls to us to make right - and as our politicians look to cash in, we the people pay out.

Never in the history of democratic society has so much been owed by so many, because of so few.

With concerns the poor will suffer for the sins of the rich – fears that paying for the past could cost our future – apathy has turned to anger.

Trust in our leaders is gone - A casualty of promises broken, expenses forged, hopes dashed. As left and right bicker many are frustrated by the same old politics in these new, changed times.

Where once the masses passively received the politicians' rhetoric, now there exists an embittered, emboldened and empowered people. A people disillusioned with politics but determined to be heard.

But whatever our numbers, do our protests really count? Are our voices not heard however loud we shout?

It's not enough to question what the politicians say: We must also question the value of our dissent, the effectiveness of our efforts, the true extent of our choices in a political system we have long taken for granted.

If power flows from top to bottom then it remains firmly in the grip of the elite, beyond the grasp of everyone else.

As we gaze intently on the details of policy and promises, we must never be blind to the realities of process and practice.

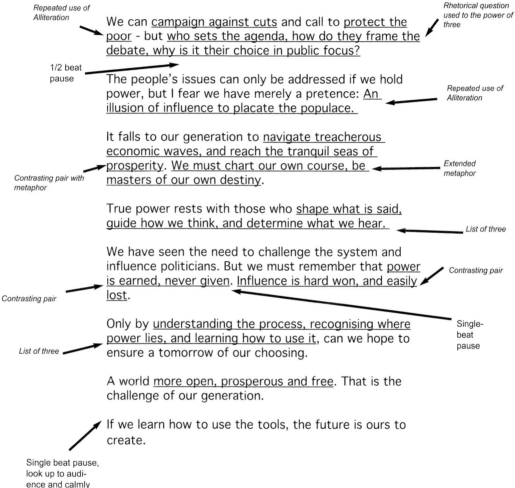

Repeated use of Alliteration

We can <u>campaign against cuts</u> and call to <u>protect the poor</u> - but <u>who sets the agenda, how do they frame the debate, why is it their choice in public focus?</u>

Rhetorical question used to the power of three

1/2 beat pause

The people's issues can only be addressed if we hold power, but I fear we have merely a pretence: <u>An illusion of influence to placate the populace.</u>

Repeated use of Alliteration

It falls to our generation to <u>navigate treacherous economic waves, and reach the tranquil seas of prosperity</u>. <u>We must chart our own course, be masters of our own destiny</u>.

Contrasting pair with metaphor

Extended metaphor

True power rests with those who <u>shape what is said, guide how we think, and determine what we hear.</u>

List of three

We have seen the need to challenge the system and influence politicians. But we must remember that <u>power is earned, never given</u>. <u>Influence is hard won, and easily lost</u>.

Contrasting pair

Contrasting pair

Single-beat pause

Only by <u>understanding the process, recognising where power lies, and learning how to use it</u>, can we hope to ensure a tomorrow of our choosing.

List of three

A world <u>more open, prosperous and free</u>. That is the challenge of our generation.

If we learn how to use the tools, the future is ours to create.

Single beat pause, look up to audience and calmly say...

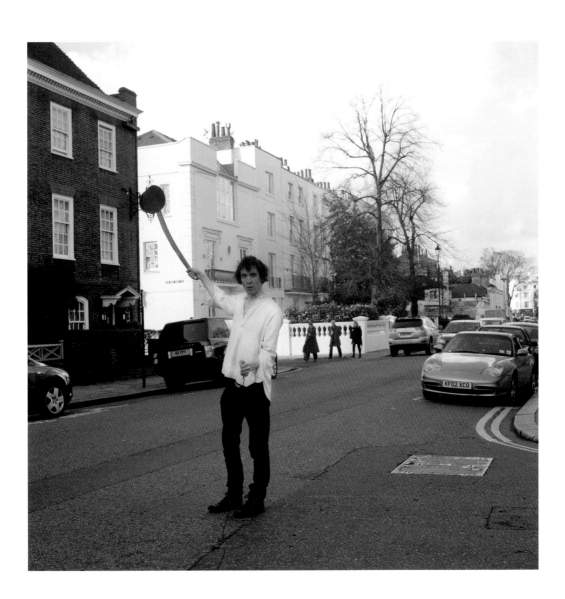

∞ File the cogs, remove the hands, stop the rotating, stop the measure, stop the repetition. Destroy your clocks. The anguish of synchronising should never be felt. Destroy repetition, destroy measure, and destroy your clocks. Time exists in the present, freedom can be experienced when the present is self-sufficient, it must obliterate itself as it proceeds. Destroy your clocks. We must live in the continuous present. What happens next is irrelevant now. Its imperative we repeatedly repeat this proposition until the true gravity of the matter is realised by all and every element of repetition has been successfully decommissioned. Destroy your clocks.

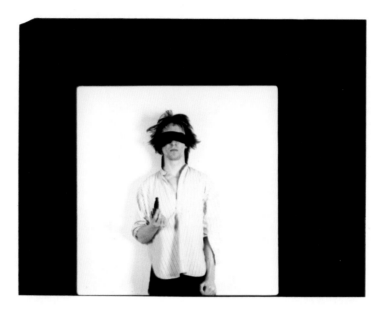

Opp. page: For the work to exist please contact the artist, Tom Pope.
On receiving the book he will make a specific gesture on
the empty page. Contact: specific.gesture@gmail.com

Marie Angeletti

marieangeletti@gmail.com
www.marieangeletti.com

By re-presenting and re-framing discordant
genres of images, and relocating them into new
systems, the work considers the appropriation
of authorship and the distribution of images.
This attempts to de-fetishise, or not, the relationship
between an artwork, its context, value and the
condition of reception.

PAGE 002
Fig. 1
Image 04, Crop 2
Red Label, Vivienne Westwood
Autumn/Winter 2011–2012

PAGE 003
Fig. 2
Factory Ceramics
Room 140–Case 18, 1900–1925

Objects 126, 127, 128, 129:

126.
Malayan girl with fruit
Austria, Vienna, 1925
Designed by Mathilde Szendro-Jaksch
Made by the Porzellanfabrik Augarten
Porcelain, painted in underglaze colours
Museum no. Circ. 201-1955
Gift of Mrs N Robbins

127.
Raven
Germany, Koppelsdorf, about 1908
Designed by Ludwig Vordermayer
Made by Heubach factory
Hard-paste porcelain, painted under the glaze
Museum no. Circ. 1289–1917
Given by HL Florence

128.
Sugar Bowl 'Donatello' pattern
Germany, Selb, 1908
Made by Rosenthal
Hard-paste porcelain, painted under
the glaze in coloured slip
Museum no. Circ. 86&A-1984
Given by Dan Klein

129.
Boy with monkey
Germany, Selb, 1916
Designed by Ferdinand Liebermann
Made by Rosenthal
Hard-paste porcelain, painted
under the glaze in coloured slip
Museum no. Circ. 127-1984

PAGE 003
Fig. 3
The Toshiba Gallery of Japanese art
Gallery 45 – Classical Tea Utensils

Tea Jar
Stoneware with brown and green glazes
Seto ware
About 1600–1700
Museum no. 17-1895

Tray
Wood or leather lacquer inlay Chinese
1550–1600
Museum no. FE.68-1974

Tea Bowl
About 1150–1250
Museum no. Circ. 310-1910

Tea Caddum with Ivorylid
Musuem no. FE 170-1877

PAGE 004
Fig. 4
The Jameel Gallery, Islamic Middle East art
Gallery 42–Safavid Metalwork

Objects 6, 7, 8, 11, 12:

6.
Brass Lampstand
Iran, 1580–1600
Brass engraved and filled with a black composition
Museum no. 1526-1903

7.
Brass Hawking Drum
Iran, about 1600
Brass engraved and filled with a black composition
Museum no. 1060-1869

8.
Brass Bath Pail
Iran, 1580–1590
Brass engraved and filled with a black composition
Museum no. 222-1892

11.
Drinking Jug with Inscriptions
Iran or Afghanistan, 1475–1500
Copper engraved, tined and filled with
a black composition
Museum no. 433-1876

12.
Brass Drinking Jug
Iran, 1500–50
Brass engraved and filled with a black composition.
Signed by Qutb al-Din Muhammad son of Abdallah
Museum no. 241-1896

PAGE 005
Fig. 5
Image 06, Crop 1
Red Label, Vivienne Westwood
Autumn/Winter 2011–2012

Image 07, Crop 1
Red Label, Vivienne Westwood
Autumn/Winter 2011–2012

Jenny Ekholm

ekholmjenny@gmail.com
www.jennyekholm.com

All is in motion, continuously floating and transforming. How do we perceive anything at all? How do we free ourselves from ourselves? I want to wander the errant path, the one that strays, so that I can listen and look around. Maybe there is an encounter to be found, one that is other, one where silence speaks, or one where the invisible begins to reveal itself, if ever so slightly.

PAGES 006–009
Light Falls on the Object
Black and white photographs, Colour photograph

117

Annett Reimer

hello@areimer.co.uk
www.areimer.co.uk

My main practice explores the relationship between body, femininity and domesticity. Throughout the work I am making use of my own body as both the subject and the object of my images. In a performative way I am using personal locations where the normality is constantly challenged through playful interactions with the space.

The work addresses the relationship between body, place and memory; the body is often surreally fractured behind everyday furniture in interiors or in landscape scenes, challenging the power of the photographic gaze.

PAGES 010–011
Untitled
2010
C-type print

PAGES 012–013
Untitled
2011
C-type print

Anne Kathrin Schuhmann

anne.schuhmann@network.rca.ac.uk
www.annekathrinschuhmann.com

The photograph is not transparent; it is opaque. One is left with looking at it. In my work I examine the potential and limits of photographic representation. There are disparate subjects and photographic techniques, but no legible narratives. I want to leave the image open, without any conclusive definition. Instead various ways of reading unfold, new sensibilities are generated.

PAGE 020
Tea Set in Turquoise
2011
C-type Print

PAGE 021
Katrina (I)
2010
C-type Print

PAGE 022
Katrina (II)
2010
C-type Print

PAGE 023
Tea Set in Green
2011
C-type Print

118

Vicki Thornton

vicki.thornton@network.rca.ac.uk
www.vickithornton.com

Timelessness is found in the lapsed moments
of perception, in the common pause that breaks apart
in a sandstorm of pauses. [1]

In my practice, I use 16mm film as a medium
by which to explore notions of the in-between,
fragmentation, and the dream sequence as devices
for the creation of open narrative form. Often
taking a single visual motif, gesture or strategy
from avant-garde cinema as a starting point,
my films are intended to act as a kind of a rebus
or picture puzzle. Through filling the gaps between the
images, text and sound presented on screen
with scenes or recollections from their own
imagination or cinematic memory, the viewer is
invited to participate within the very structure
of the film itself.

[1] Smithson, Robert, in "Incidents of Mirror-
Travel in the Yucatan" (1969) in Jack Flam
ed., *Robert Smithson: The Collected Writings*
(Documents of Twentieth-Century Art),
University of California Press, 1996, pp.
121–122.

PAGES 024–027
The Tender Interval
2010
16mm film with optical sound
Duration: 5 minutes 40 seconds

George Petrou

george.petrou@network.rca.ac.uk
www.georgepetrou.com

Love. Fall. Float amongst notions. Love. Negotiate.
A self rises into the rupture of its own splitting.
Confront. Face unknown, eluding others.

PAGES 028–029
When We Split in Two
2011
Video still

PAGES 030–031
George Petrou/Alexander García Düttmann
What if I Wanted to Turn into Your Prosthesis?
2011
Image/text work

Megan Powell

m.powell_info@yahoo.co.uk

I work with auto/biography and its displacement. Using personal testimony and external often unreliable sources of evidence. To construct parallel fictionalised personal narratives, which expose playful incoherences in memory, identity and character construction.

PAGES 032–035
Transcribed memories of E.M.
2011
Digital

Hitomi Kai Yoda

info@hitomiyoda.com
www.hitomiyoda.com

I am strongly drawn to power relations, control, authority, and transactions, especially in relation to 'the image'. My awareness of these factors stems from my childhood experiences of a hybrid culture, at home, school, and in society.

Through my practice, I attempt to challenge constructs of both the authoritarian and unauthoritarian. The form taken is a process of the mutual connections and influence between them both, as well as considering wider social realities.

Hitomi Kai Yoda
PAGE 036
1. Ongoing project
2011
Colour photograph

PAGE 038
2. Untitled, Canary Wharf
Untitled
2010
Lambda print

4. #33,
Chameleon People
2007
Lambda print

Hiroshi Yoda
PAGE 037
3. Boxes in the Bathtub
2010
Black and white photograph

5. Hitomi with Violin
Hitomi, My Son
1993
Colour photograph

PAGE 039
6. Two Tangerines
Obsession
1992
Colour photograph

Jonny Briggs

jonny.briggs@network.rca.ac.uk
www.jonnybriggs.com

In search of lost parts of my childhood I endeavor to think outside the reality I was socialised into and create a new one with my parents and self. Through this I question the boundaries between us, between adult and child, love and resentment, expressed and reserved, real and fake in an attempt to revive my unconditioned, uninhibited self. Striving to escape my closing adult mind, photomontage is used as a medium to escape the normal, look back and re-capture childhood nature through my cultured adult eyes.

PAGES 046–048
Into the Forest / Out of the House
Photographic print

PAGE 049
Comfortable in my Skin
Photographic print

Esther Teichmann

esther.teichmann@network.rca.ac.uk
www.estherteichmann.com

My practice moves across still and moving image, collage and painting, creating alternate worlds, which blur autobiography and fiction. Central to the work lies an exploration of the origins of fantasy and desire and how these are bound to experiences of loss and representation.

Working with intimate subjects, such as mother and lover, my practice looks at the illusion that to survive without the existence of the other would be an impossibility. Both bodies remind us precisely of our own separateness; exactly at the point of contact with the other, we become most acutely aware of our own skin, our own boundaries. These ideas of an impossible return, of grief and a sense of inherited home-sickness, return us to the womb, to the original home of mother and beyond.

This image of otherness, hails the maternal as an image of escape, a place to travel to: backwards and towards.

Teichmann's utopian island-world lies somewhere between black and blue seas, between here and now and the fantasy of where one might go, or perhaps, even, where one has been. (Carol Mavor)

PAGES 050–052
Diptych I and II from Mythologies
2011
Fibre based prints

PAGES 051–053
Text from Drinking Air
2011

Tom Mills

info@tommills.net
www.tommills.net

My work is an exploration of materiality and perception through a photographic and sound based practice. The interaction's relationship with the camera and the microphone reveal new ways of understanding the material, the meaning changing throughout its duration.

PAGES 054–059
Turn
2011
Mixed media

Emma Critchley

info@emmacritchley.com
www.emmacritchley.com

My practice seeks to develop a deeper understanding into what happens both physically and psychologically when we become immersed within the underwater environment. When submerged beneath the surface our basic structure of being changes. We become suspended in a threshold state, held within a fragile, transitory temporality sustained by the breath: and it is this suspension that creates a becoming of both body and mind.

PAGES 058–059
Suspended Silence
2011
Lambda print

PAGES 060–061
Jane #1 & Jane #2
2011
Lambda prints

Kevin Gaffney

kevin.gaffney@network.rca.ac.uk
www.kevingaffney.co.uk
www.unnameable.net

The Unnameable is a film collaboration between myself and Sally-Anne Kelly who I have been working with since 2009. The work is a hybridisation of our individual practices of performance, photography, video, writing and sculpture. *The Unnameable* tells the story of a boy who grows up feeding an invisible elephant in his room. His psyche splits as he attempts to imagine life without the elephant and we follow him through his imagination, in and out of his consciousness.

PAGES 062–065
The Unnameable
Images
Kevin Gaffney & Sally-Anne Kelly
2011
Video Stills

Text
Kevin Gaffney
2011

Nadege Meriau

nadege@nadegemeriau.com
www.nadegemeriau.com

When I think about Immersion I also think about romanticism and the sublime but what I am currently investigating through my own practice is whether it is possible to create images which are immediate and immersive at the same time, close ups that are also landscapes, sculptural, sensuous forms that are also spaces the viewer can dwell in.

I am exploring the possibility of photographing the non-human flora, less from a detached anthropomorphic perspective, and more through my own transition to ground level, with my camera, coming closer to the plant itself and embodying the imagined perspective of the worm.

Gaston Bachelard's concept of intimate immensity (reminiscent of the romantic longing to "incorporate infinity") and my interest for biomimicry are steering my investigations.

Worms are interesting to me as metaphors for the creative process, or as a possible model for a more embedded and embodied way of being in the world.

Roots evoke issues of belonging which are the very beginning of the concept of Ecology ("Science dealing with the relationship of living things to their environments, coined by German zoologist Ernst Haeckel (1834–1919) as Okologie, from Gk. oikos "house, dwelling place, habitation" (see villa) + -logia "study of" (see -logy).

PAGES 074–077
Constellation Solanum Tuberosum
2011
Digital C-print

123

Greta Alfaro

gretalfaro@yahoo.es
www.gretaalfaro.com

In a continuous search for equilibrium,
like funambulists, like on the edge of the abyss,
we are always ready to fall into chaos.

The hidden and the unexpected rise in
spite of the rules believed to control violence
and vulnerability.

In the gap between private and public life
we visualise our everyday life hypocrisy.

PAGES 088–089
Iron Cross
2011
Found images

PAGES 090–091
After a Burial
2011
Found images

Rachel Louise Brown

rachel.brown@network.rca.ac.uk
www.rachel-brown.com

In my practice the landscape becomes a cinematic
stage: locations where strangers become the
potential characters to inhabit them. Through
one process, I explore my psychological reaction
to unfamiliar territory. With memories created
by cinema, literature and imagination I explore
and visualise the unknown alone. Experiencing fear
and curiosity, I abstract the real into a photograph.
Through a second process I occasionally invite
strangers to inhabit the 'stage'. The resulting images
are collaborative: a cross between my expectations
as 'director' and the subject's presentation.
Through these 'castings' I explore how narrative,
body language, representation, sexuality and
power relations are created for the lens.

PAGE 092
Sail. The Male Pin Up Casting, NYC
2011
Lambda print

PAGE 093
Spencer. The Male Pin Up Casting, NYC
2011
Lambda print

PAGE 094
Ivan. The Male Pin Up Casting, NYC
2011
Lambda print

PAGE 095
Pacifico. The Male Pin Up Casting, NYC
2011
Lambda print

Helen Cammock

helen.cammock@network.rca.ac.uk
www.helen.cammock.co.uk

Thinking about who represents whom, and for whom, is key to my practice. I'm interested in this dynamic and in stories that contribute to a broader understanding of the fabric of contemporary society. This includes the legacies that have brought us to this point in national and global frameworks of existence. I explore the relationship between the individual lived and collective experience, in relation to the structural frameworks that are both political and social in different ways through the still and moving image. My personal experience and the fragmented narratives that place my understanding in the contemporary context all contribute to the stories I tell.

PAGES 096–097
45c Kappelbracken
2011

PAGES 098–099
Storyboard layout of the slideshow Fabric
2010

Andrew Lacon

contact@andrewlacon.co.uk
www.andrewlacon.co.uk

Questioning the way we deal with ownership of space and boundaries, I enquire into the familiar and the extraordinary. Based on individual experiences, the transcendence of everyday life in moments of heightened perception, I question the way we experience the English landscape. Place, time and memory feature within my work whilst highlighting political, social and class issues within suburban England. The ubiquitous nature of photography is interrogated through sculptural acts in and with the landscape.

PAGE 104
Black Country, England. Now.
2011
C-type print

PAGES 105–106
Grey
2011
1 colour offset print on 170gsm FSC certified paper

PAGE 107
Galvanised Sceptre
2011

C-type print
Rebecca Court

rebecca.court@network.rca.ac.uk
www.rebeccacourt.co.uk

My practice explores the position of individuals,
in relation to the political and social structures
in which they live. Through an interest in three-
-dimensionality, materiality and the physical
relationship between the work and viewer,
my inter-disciplinary installation based work
questions the mechanisms of political language.
Often manifest through site-specific responses,
the strategies used to acquire and control power
are exposed, as is the information fed down
to us through systems of communication.

PAGES 108–111
Political Speech
2011

Tom Pope

tomleonardpope@yahoo.co.uk
www.tompope.co.uk

An absurdist embarking on excursions in the public
commons, conducting thought experiments that
stem from the ungraspable. Utilising performative
strategies in order to highlight the discourse
between a potentially time-based photography
and notions of the event. Gesture manifests itself
through the irrational and playful situation whilst
exploring existential truths. Subsequently,
the performative photograph or moving image
of an event and the event itself form a creative
dialogue. It's this antidote that seeks interaction
with the audience.

PAGES 112–113
Clock House
2011
C-type print

PAGES 114–115
Gesture
2011
Polaroid and performative instruction

Rut Blees Luxemburg

Rut Blees Luxemburg is an artist whose large-scale photographic work show the public spaces of the city. She creates immersive and vertiginous compositions that confront established perceptions of the urban artifice. Her work is woven from literary and philosophical references which constitute a rigorous frame of thought and make the tension in her photographs possible.

Rut Blees Luxemburg's work includes the collaborative opera *Liebeslied/My Suicides* and the recent public art installation *Piccadilly's Peccadilloes* at Heathrow. Her work has been exhibited internationally and is in the public collections of the Tate Modern, the Victoria & Albert Museum and the Centre Pompidou.

Vanessa Boni

Is a curator living and working in London. She is a graduate on the Curating Contemporary Art MA at the Royal College of Art and has curated and organised various projects and exhibitions, most recently including *Gossip Scandal and Good Manners* at The Showroom, London, 2010 and *Off the Record* in collaboration with ResonanceFM and Wysing Arts Centre, Cambridgeshire, 2011.

Mike Sperlinger

Mike Sperlinger is Assistant Director of LUX, London. As a freelance writer, he has written for magazines and journals including *frieze*, *Art Monthly*, *Radical Philosophy* and *Afterall*. He is the editor of two books —*Afterthought: New Writing on Conceptual Art*, 2005 and *Kinomuseum: Towards An Artists' Cinema*, 2008.

Olivier Richon

Since the 1980s, Richon has continued an ongoing investigation into the artifice of representations, primarily through photography. He understands photography as an art of visual quotations, using a highly individual technique which combines a painterly aesthetic with a pin-sharp, almost hyperrealistic attention to detail. Influential to a generation of practitioners, his work can be seen as an ongoing form of research into image and language. He is Professor of Photography at the Royal College of Art, London.

Simon Baker

Simon Baker is Tate's first Curator of Photography and International Art. He has published on Surrealism, photography and contemporary art, and curated the exhibitions *Undercover Surrealism*, 2006 and *Exposed: Voyeurism, Surveillance and the Camera*.

Leslie Dick

Leslie Dick is Co-Director (with Martin Kersels) of the Art Program at CalArts, where she has taught since 1992. Having published three works of fiction, notably *The Skull of Charlotte Corday and other stories*, 1995, recently she has been writing about art for various publications, including *X-TRA*, *Eyeline*, and *East of Borneo*, on topics such as Walid Raad, the Hyperbolic Crochet Coral Reef, and the work of Paul Thek. In March 2010, she presented Jacques Lacan's The Mirror Stage: A Multimedia Performance (with the participation of Das Racist and DJ Spooky) as part of the Whitney Biennial in New York.

Acknowledgements / Imprint

All images courtesy of the artist unless
stated otherwise

PAGES 042–043
Let's Take Back Our Space, courtesy of Marianne Wex

PAGES 066–073
The photographs by Le Charles are illustrations
for *Mimetisme et psychasthénie légendaire* by
Roger Caillois, published in *Minotaure no 7*, 1935.
Albert Skira, Editeur à Paris

PAGE 079
Anonymous, *House on Fire*, c. 1950, courtesy
Ordinary-Light Photography

PAGES 084–085
Lewis Baltz, *Continuous Fire Polar Circle*, (element1),
1986, courtesy of the artist and Gallery Luisotti

Edited by
Rut Blees Luxemburg and Vanessa Boni
with assistance from Douglas Park

Thanks to
The Photography Department of the Royal College
of Art : Professor Olivier Richon, Hermione Wiltshire,
Peter Kennard, Rut Blees Luxemburg, Sarah Jones,
Yve Lomax, Francette Pacteau, Alexander García
Düttmann, Stuart Croft, Nigel Rolfe, Susan Butler,
Åsa Johannesson, Lewin St Cyr, Jan Naraine, Simon
Ward, Kam Raoofi, George Duck, Roddy Canas
and Claire Smithson.

Royal College of Art
Postgraduate Art and Design

architecture art design
fashion history photography
theory and things

**black dog
publishing**

www.blackdogonline.com london uk